Pastel Pointers

Richard McKinley

TOP SECRETS FOR BEAUTIFUL PASTEL PAINTINGS

NORTH LIGHT BOOKS

Cincinnati, Ohio

www.artistsnetwork.com

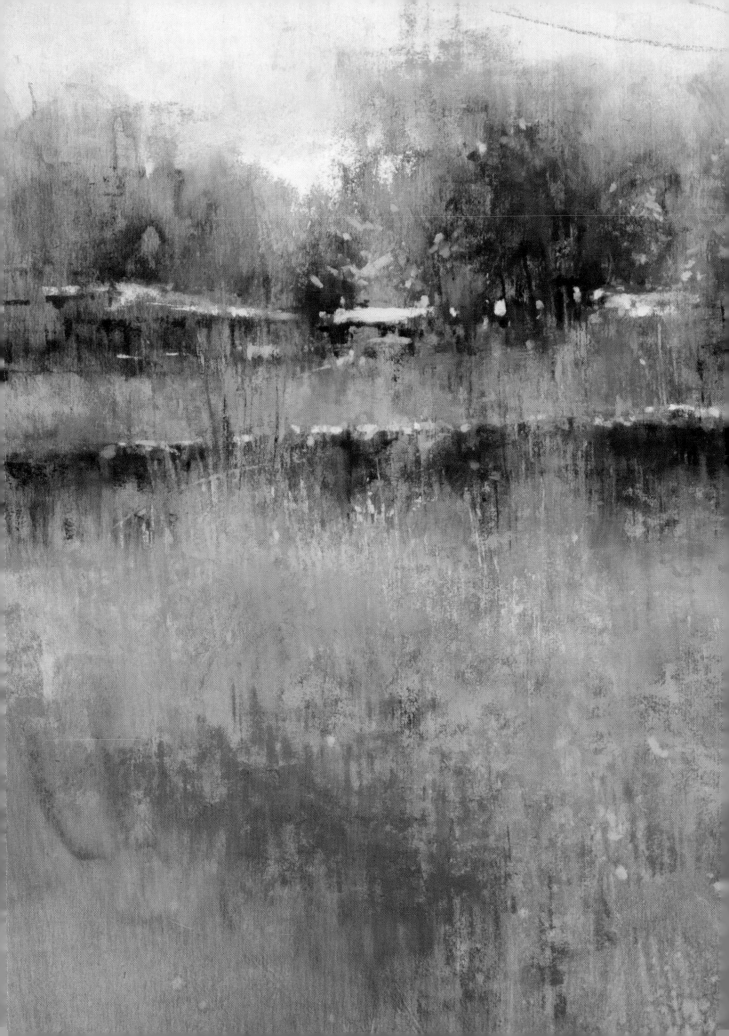

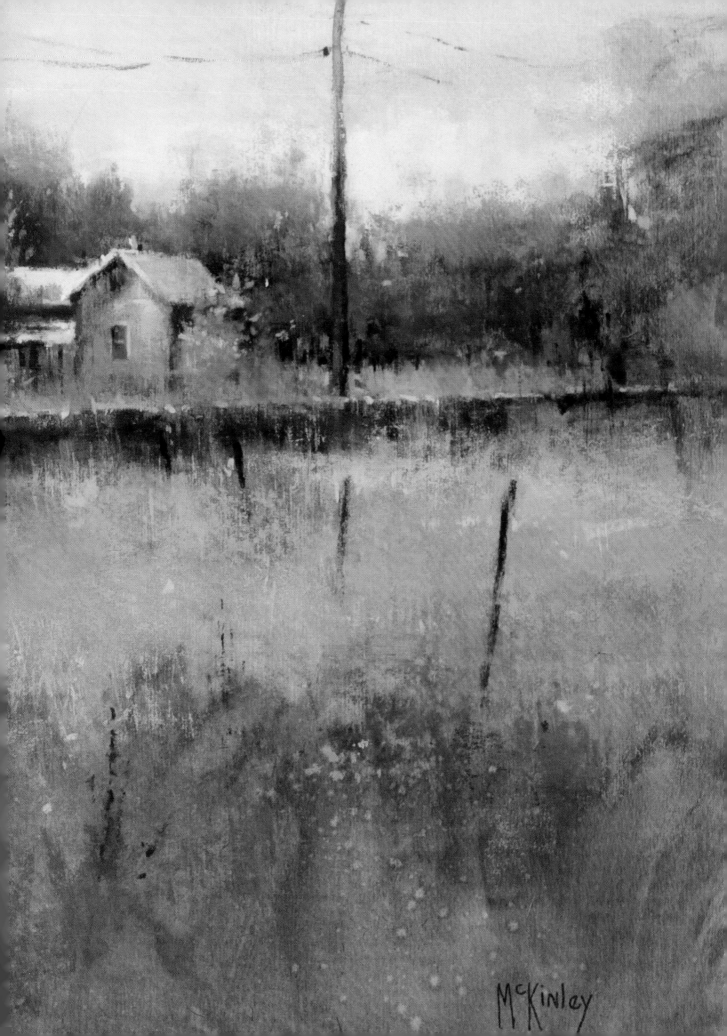

Cascade Glow–detail (cover), 22" × 28" (56cm × 71cm)
Summer Color (page 2), 12" × 18" (30cm × 46cm)
Spring Rains (page 7), 18" × 15" (46cm × 38cm)

PASTEL POINTERS. *Copyright © 2010 by Richard McKinley.* Manufactured in the U.S.A. All rights reserved. No part of this book may be reproduced in any form or by any electronic or mechanical means including information storage and retrieval systems without permission in writing from the publisher, except by a reviewer who may quote brief passages in a review. Published by North Light Books, an imprint of F+W Media, Inc., 4700 East Galbraith Road, Cincinnati, Ohio, 45236. (800) 289-0963. First Edition.

Other fine North Light Books are available from your local bookstore, art supply store or online supplier. Visit our website at **www.fwmedia.com**.

14 13 12 11 5 4 3 2

DISTRIBUTED IN CANADA BY FRASER DIRECT
100 Armstrong Avenue
Georgetown, ON, Canada L7G 5S4
Tel: (905) 877-4411

DISTRIBUTED IN THE U.K. AND EUROPE
BY F+W MEDIA INTERNATIONAL
Brunel House, Newton Abbot, Devon, TQ12 4PU, England
Tel: (+44) 1626 323200, Fax: (+44) 1626 323319
Email: postmaster@davidandcharles.co.uk

DISTRIBUTED IN AUSTRALIA BY CAPRICORN LINK
P.O. Box 704, S. Windsor NSW2756 Australia
Tel: (02) 4577-3555

Library of Congress Cataloging in Publication Data
McKinley, Richard
 Pastel pointers : top secrets for beautiful pastel paintings
/ Richard McKinley. -- 1st ed.
 p. cm.
 Includes index.
 ISBN-13: 978-1-4403-0839-0 (pbk. : alk. paper)
 1. Pastel drawing--Technique. I. Title.
 NC880.M39 2010
 741.2'35--dc22
 2010028709

edited by **SARAH LAICHAS**
production edited by **MAIJA ZUMMO**
designed by **JENNIFER HOFFMAN**
production coordinated by **MARK GRIFFIN**

About the Author

Richard McKinley has been a professional artist for 38 years and has more than 35 years of teaching experience. He writes a weekly blog for *The Pastel Journal* titled *Pastel Pointers* that has appeared on www.artistsnetwork.com since 2007, and he's written for the periodical since 2003. He's taught and participated in national and international workshops for more than 30 years. His work is shown in several national galleries, and he is an Artist Member of the Salmagundi Club of NYC, a Signature Member and 2010 Hall of Fame inductee of the Pastel Society of America, a Signature Distinguished Pastelist with the Pastel Society of the West Coast, a signature member of the Northwest Pastel Society, and a member of the Oil Painters of America. His work has been included in several North Light Books including *A Painters Guide to Design and Composition*, *Painting with Pastels* by Maggie Price and *Pure Color: The Best of Pastel*. Richard has also produced two instructional DVDs on pastel painting for ArtistsNetwork.tv. Visit his website at www.mckinleystudio.com and blog at http://pastelpointersblog.artistsnetwork.com.

Metric Conversion Chart

To convert	to	multiply by
Inches	Centimeters	2.54
Centimeters	Inches	0.4
Feet	Centimeters	30.5
Centimeters	Feet	0.03
Yards	Meters	0.9
Meters	Yards	1.1

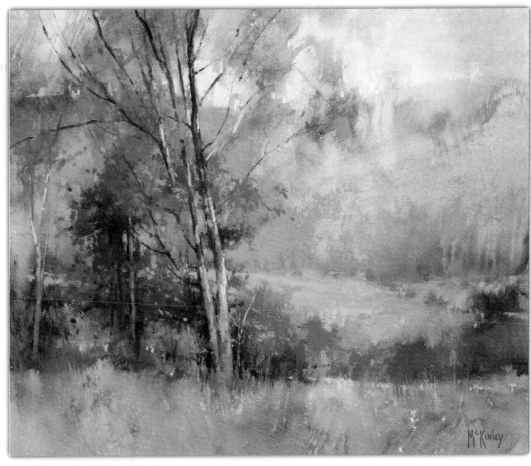

A Gentle Rain, 15" × 18" (38cm × 46cm)

Acknowledgments

Everything shared in the pages of this book comes from the applied lessons of those gracious artists that have provided knowledge and inspiration to myself and other aspiring painters over the years. A special thanks is given to all the students I have been fortunate enough to interact with. Far more has been learned from them than any other source.

Credit must be given to: my mother Beneva McKinley, for instilling a sense of artistic wonder in me at an early age; to my high school art instructor James Snook, for seeing potential and challenging me to use it; to my first artistic mentor Margaret Stahl Moyer, for providing guidance and discipline; and to master painter Albert Handell, for giving permission to listen to my inner artistic voice.

Heartfelt thanks are given to Janie Hutchinson and Maggie Price for having the vision to found *The Pastel Journal* and for allowing me to first publish in its pages.

Gratitude is owed to the wonderful team at F+W Media: publisher Jamie Markle and editorial director Pam Wissman, for having proposed the project and guiding it along to completion; to editor Sarah Laichas, for all her patience and hard work in the laborious task of pulling together all the years of writings; to all the editors and editorial staff I have been fortunate enough to work with: Maureen Bloomfield, Chris McHugh, Jessica Canterbury and Sarah Strickley; and most of all, the one person that deserves the credit of dual authorship, *Pastel Journal* editor Anne Hevener, for making my words coherent and sound so good over the years.

Dedication

This book is dedicated to all of my painting friends for years of artistic camaraderie and to Don Robertson for his unwavering support of my artistic journey.

Contents

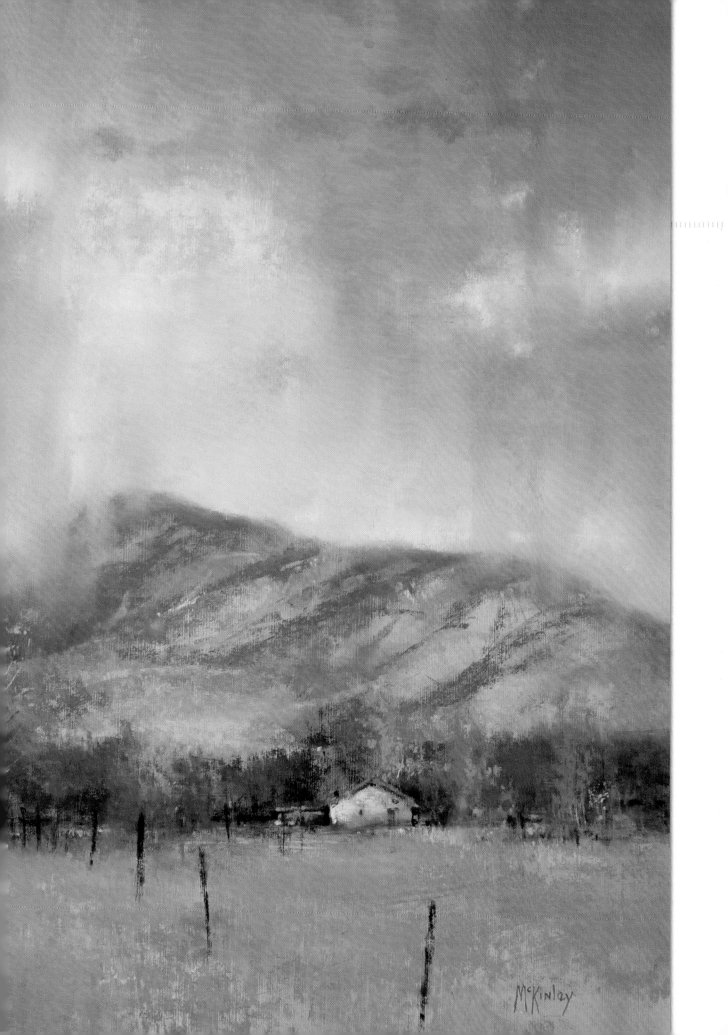

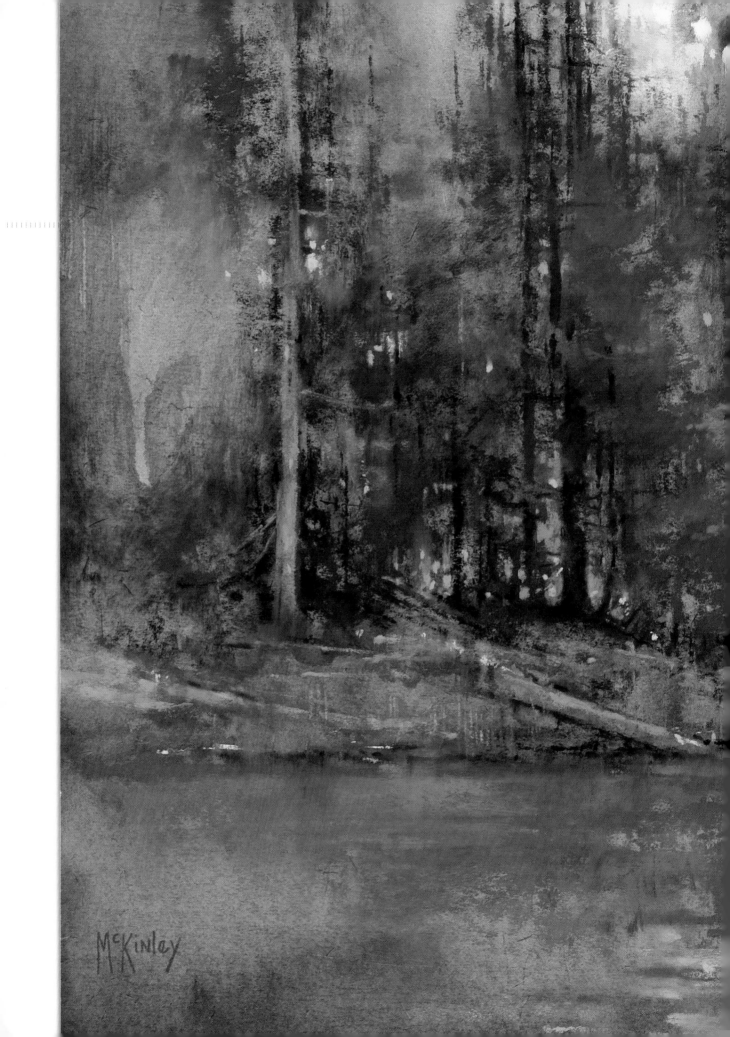

Introduction

I WAS HUMBLED BACK IN 2003 TO BE ASKED TO WRITE FOR *The Pastel Journal*. What did I have to share? Little did I know it would lead to over twenty-five columns and become one of the most rewarding experiences of my artistic life. In 2007, editor Anne Hevener approached me with the idea of doing a blog about pastel. I didn't even know what a blog was. With encouragement from the staff at F+W Media, the weekly posts began, covering topics from palette choices to what we listen to while painting. As the material accumulated, the idea of a compilation ensued. Then the herculean task of organizing began. With the considerable help and patience of editor Sarah Laichas, it has finally come together.

My introduction to pastel began in 1975 when a fellow artist that admired what I had been doing with oil paint handed me my first set of pastel sticks. Instantly, I was hooked. The immediacy of its application and its forgiving nature made it a pleasure to paint with. Even though I continue to work in other media, pastel will always be a major part of my artistic expression.

Teaching has allowed me to become more analytical, something that comes naturally to my personality. By attempting to communicate the concepts of why we do what we do when painting, I have had to spend considerable time researching the theories of representational painting. This research is evident in the concepts expounded in the *Pastel Pointers* columns, blogs and now within the covers of this book. Thus many are not my original ideas or concepts, but retold through my experience.

What I hope to share within the pages of this book is not the formula of how to paint a pastel painting, but a pool of information that may provide some tips to help you make your paintings better, the process easier, and inspire you to enjoy all of the diversity that is pastel.

The Cove, 14" × 14" (36cm × 36cm)

Materials

1

Evening at the Malheur
12" x 16" (30cm x 41cm)

11

Picking Pastels

Every pastel painting begins with the pigments in your palette. It's from this source that you make the choices that produce your final statement. Having a good system facilitates an efficient relationship between thought and choice of pastel stick, leaving you better able to accomplish a successful outcome with less frustration and distraction.

Palette Basics

The palette needs to include every color family, represented in a whole range of values from dark to light, as well as neutral tones that represent these values mixed together. Whereas painters who use a wet medium might have as few as three primary pigments and white on their palettes, pastelists need considerably more to be able to reproduce what lies in front of them.

Understanding Color

Choosing pastel sticks can be a daunting experience. A working knowledge of hue, value and chroma makes this much easier, and this begins with a solid understanding of the color wheel. When it comes to understanding color, even someone who never plans to paint with anything but pastel can benefit from some experimentation with wet paint. As any wet-media artist can attest, learning how to mix individual hues to arrive at specific tones takes trial and error. Individual pigments have their own personalities and, when mixed with others, can create some exciting outcomes.

Hue, Chroma and Value

To work well, the palette needs a logical system that represents the three aspects of color: hue (the individual color family), chroma (the intensity or saturation of said color) and value (the relative lightness or darkness of said color). Having colors laid out representing a color wheel clarifies their natural relationship, facilitating more harmonic choices. Placing values with light at the top and dark at the bottom allows for quick selections within a variety of hues of similar value.

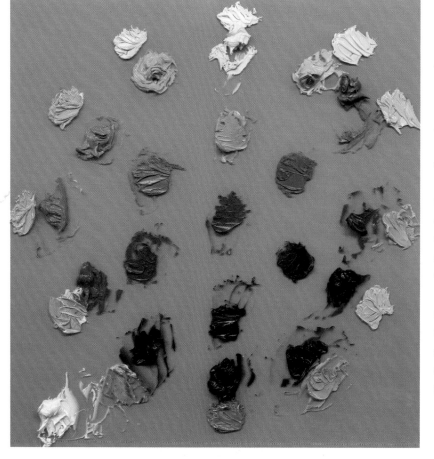

EXPERIMENT WITH OILS TO UNDERSTAND COLOR

I recommend using oils to strengthen your understanding of color. As a wet medium, oils stay wet long enough to allow for prolonged mixing and experimentation. Use a minimum of four pigments: yellow (Cadmium Yellow Light), red (Cadmium Red or Naphthol Red), blue (Ultramarine Blue), and white (Titanium or a mixed white). Place them on a palette (a piece of glass works well and is easily cleaned). Then, experiment; play and mix with abandon, taking note of the effects.

Here, I've used just four oil colors—blue, red, yellow and white—to mix colors that represent the color wheel. The perimeter shows the colors with the addition of white, and in the center, you can see the natural graying of complementary colors.

Arranging Your **Palette**

A pastel palette should be regarded as a working palette rather than a one-brand assortment. Even if only one brand is utilized, it should be arranged in a way that represents color and value relationships.

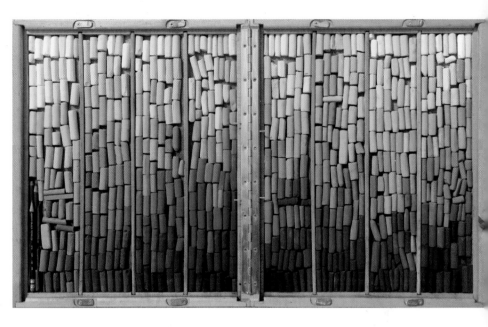

The Setup

My palette is set up for a right-handed painter. It begins with yellow on the left, and progresses to green on the right (a left-handed painter should reverse the placement).

I segregate a selection of neutrals, or grayer hues, on the right-hand side of the palette. These provide a visually pleasing representation of the possibilities of weaker tones. The neutrals are often overlooked if placed within their original color family. By setting them aside, a painter is better able to see the individual possibilities they provide.

Making Selections

There's a shared misconception among pastelists that simply acquiring more pastels will make things easier. And while it's true that working with a palette that's too limited can be frustrating, it's also true that too many sticks can be confusing, leading to disjointed paintings that lack overall harmony. When selecting pastels for your palette, therefore, think of it as you would mixing wet paint. Consider what colors, values and tones you would most often utilize, and then weight your palette accordingly. Make sure a full spectrum of color and value is represented.

Hard vs. Soft Pastels

When choosing between harder and softer pastels, remember this old oil painters' mantra: thin to thick, dark to light, dull to bright, and soft to sharp. This guideline has been the foundation of most representational painting over the centuries.

Since pastel shares a kinship with oil, it works well to apply this principle to pastel paintings and palette selections, utilizing harder pastels in the initial dark, dull and thin beginnings before migrating to softer, luscious pastels for the lighter, brighter and thicker final applications.

Keep in mind that individual pastel brands have their own characteristics. Some are very soft and velvety, while others are slightly hard and gritty. Building a palette ultimately comes down to individual choice. There are so many wonderful brands available and so many duplicate colors between them. Individual taste has to be honored. Experiment with as many brands as possible before committing resources to a major expenditure.

HOW I SEPARATE MY PALETTE

I use the layout of my palette to help me control the value and color in my paintings. I start by separating pastels into color families. Yellow begins on the far left, followed by orange, red, violet, blue and green. Then I further divide the pastels according to value. The lightest value pastels are at the top; the darkest at the bottom. I also separate the grayed, more neutral colors from their color families and relegate them to one side. Thus I'll have gray-yellow, gray-red, gray-blue and so on. Finally, I segregate pastels according to their physical makeup; i.e., harder and softer varieties.

Studio vs. Field Palette

In the studio, it's much easier to set up large areas for pastels and have a variety of sticks at arm's reach, but in the field a painter has to travel light. Fortunately, there are pastel travel palettes available that make this much easier. I've had a good experience with pastel cases from both Heilman Designs and Dakota Art Pastels. Both companies offer wooden cases in a range of sizes that make travel much more efficient. The cases open like a briefcase to provide storage on both sides, which allows for easy arrangement of the individual pastels.

For travel, I find it's best to mix brands to create a working palette. Mine consists of harder pastel brands weighted towards the darker, neutral areas of the palette, along with softer, buttery pastels that fill in the lighter bright areas (see the photo of my travel palette).

My palettes, both in the studio and field, have become a natural extension of my mind, eye and arm. By using a consistent arrangement, I never have to second-guess what I'm looking for; my hand simply goes to the right area of the palette, which frees me to concentrate on the mental chess game of painting the picture.

Regardless of which brands you eventually commit to, it's paramount to have a systematic arrangement. If your palette is arranged differently for field painting, you'll find your concentration broken as you hunt for that specific hue or value.

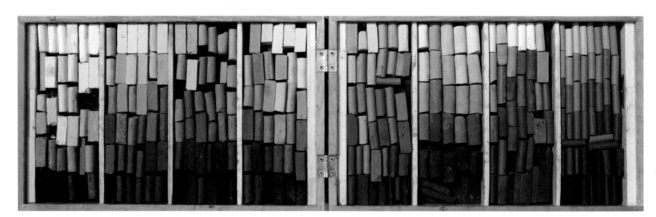

MY FIELD PALETTE

My traveling palette is much more compact and contains about 260 pastel sticks broken in half. It is arranged like my studio palette to keep my work flowing smoothly. My studio palette contains about 600 pastel sticks broken in half.

Tracking and Replacing Your Pastels

Replacing a pastel stick can be a problem in a palette of mixed brands. It can help to label a palette with the majority brand, if there is one, and then make notes with handmade color swatches of the supplemental brands. This way, when you notice a stick wearing down, you can start your search within the colors of the main brand first. If you can't find it there, then you can refer to your pastel notes.

Holding the Pastel

We each come into our own technique with time and experience. Mine is to think like a wet painter and apply the pastel as if it were a brushstroke. A nice side effect of this is that my oils and pastels are hard to tell apart because they both retain a similar application, which represents my style.

The Surface

Every surface accepts the pastel differently and only through experimentation will it be clear how best to apply the pastel.

The Brand

Some brands of pastel flow like butter onto the surface and others scrape across it in a gritty fashion. For this reason, I prefer to have an assortment of brands at my fingertips.

The Application

The third factor is how much pressure will be used, and this is the thing we have the most control over. Inherently, we might have a light touch or a heavy hand, but with practice, we can learn to control the pressure applied. Facilitating a varied touch will allow for a variety of applications.

THE THREE-FINGER HOLD

To hold the pastel stick, I use a three-finger hold. I came to pastel having worked in oil for a number of years and this influenced my technique. I want the pastel to go onto the surface like a brush applying paint and I've found that by holding the stick between my thumb, forefinger and middle finger I can utilize its side for broad strokes. If I rock it up slightly, I create a hard- and soft-edged stroke. If I tip it up even more and work with the forward edge and dab it, I create smaller dashes. These motions all relate to common brushwork I'd been using in my wet painting that have stayed with me all of these years.

Selecting the Right Pastel Stick Size

Selecting the right stick size varies depending on the size of strokes desired. Most of the pastel pieces in my cases range from a third- to a half-stick (for an average-size major pastel brand, about 1 to 1½ inches [3 to 4 centimeters]). For a larger painting I would use larger pastel sticks. This may be why most of my paintings range from 9" × 12" (23cm × 30cm) to 18" × 24" (46cm × 61cm), as the sticks I have allow for strokes that work well within those sizes.

Cleaning Your Pastels

No matter how neat you are, or how tidy you keep your painting equipment, pastel dust will eventually contaminate the outer surface of individual sticks in your pastel palette, making them hard to identify. If you frequently work with extremely soft pastel brands or tend to apply heavy applications of pastel above an open pastel palette, you have seen how quickly the dust accumulates, making all your sticks appear grayish. We expect a stick to make a mark that represents our intentions. If the outer surface of the stick is contaminated, this can prove difficult.

One of the best methods of cleaning pastels is to place them in a lidded container containing course grain, and then gently agitate. A simple household plastic container will work well. For the grain choice, a common rice or cornmeal will suffice. Since this quickly becomes contaminated with pigment, there's no need to purchase the pricier organic or name brand variations. Depending on how many pastels are to be cleaned, the container can be small or fairly large.

Some artists even travel with their pastels in these grain containers. Before painting, they remove the sticks and arrange their pastel palette. When done, all the sticks go back in the container for safe, clean transportation. No vigorous agitation is required to accomplish the goal of cleaning the outer surface of the pastel stick. If you frequently clean a large volume of pastels or plan to use the containers for transporting pastels, a makeshift strainer can be fabricated out of mesh, making it easier to fish the sticks out of the grain.

Another consideration is to purchase a strong pastel palette box that prevents the individual pastel sticks from moving around in transport. As they bump together, dust is produced, leaving varied pigment deposits that hinder identification. Frequent hand washing will also help. As we change sticks, we carry pigment on our hands from one stick to another. Over the years I have acquired the habit of holding a soft paper towel in my non-painting hand. When I set a stick down, I automatically wipe my hand on the towel before picking up a new one. Placing a catch trap under a painting is also helpful. The dust from the pastel will migrate down into the trough instead of into your palette.

Note also that there are some artists who enjoy the spontaneity of the "surprise color." It's become a part of their technique. They become motivated by the challenge it provides. If you're not one of those adventurous souls, it will serve you well to occasionally clean your pastels to allow the true pigment of the stick to re-appear.

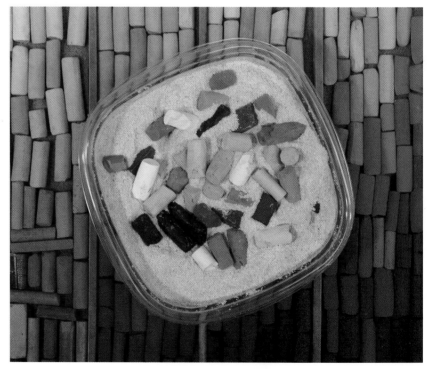

CLEAN YOUR PASTELS IN GRAIN
Place your sticks in grain and agitate to remove unwanted pastel dust.

Recycling Leftover Pastels

Quality pastels are expensive and I hate to waste even the littlest sliver. Over time, our precious sticks wear down to tiny nubs, crumble when the paper label is removed, or turn to dust that accumulates below our paintings (which I carefully collect into jars). All of these leftover pastel fragments can be reworked into viable forms.

I keep it simple, because I don't want to produce pastels from scratch; I just want to redeploy my leftovers. For health reasons, wear a mask that covers your nose and mouth as well as surgical gloves to protect your hands. Never blow the dust around; instead, use a damp rag to wipe up any messes. Along with the pastel fragments or collected dust, you'll need a large smooth surface for mixing (a marble tile or ¼-inch [1cm] picture glass surface works well), utensils for grinding the pigments together (a 1¼-inch [3cm] putty knife from the hardware store will work), distilled or purified water, and paper towels.

First, place the pastel fragments and/or dust on the mixing surface and carefully grind it by flattening the putty knife blade into the pile. Keep reforming the mound and repeating the grinding procedure until no more grit is felt and the pastel fragments have been pulverized into a pile of pigment. This can take quite a bit of effort and repetition. If you leave too much grit, there will be surprise flecks of color in the stick you produce. Create a small cone shape (a volcano-mountain shape) out of the pigment and make a crater in the center. Next, slowly add water, a drop at a time. It's better to add too little than too much. Since you're working with what was once a pastel, the binder and preservatives are already part of the mix. Allow some time for the water to soak in and then slowly fold the pigment back into the mix until a paste is created, much like a heavy dough.

Pick up with your fingers the amount you wish to form into a shape and gently roll this out on a paper towel into a stick form. (Some artists like to pat the paste into pillows or other shapes, rather than a log shape; feel free to experiment.) Leave the pastels on the towel to dry (usually a few days) and then place them back in service in your pastel palette. You can mix different pastel colors to obtain interesting colors or mix a lot of fragments and obtain grays (neutrals). But don't fall too in love with the stick you produce, since it's one of a kind!

Another way of utilizing these tiny pastel bits is to grind them down along with a white pastel stick and create tints. A little piece of strong pigment will go a long way in making a lighter tint.

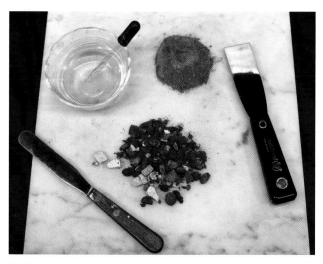

TOOLS FOR RECYCLING YOUR LEFTOVERS
To recycle pastel, you'll need a pile of pastel fragments, the pulverized pastel dust (here shaped into a mountain), and a few mixing tools: marble tile, water, a putty knife and a palette knife.

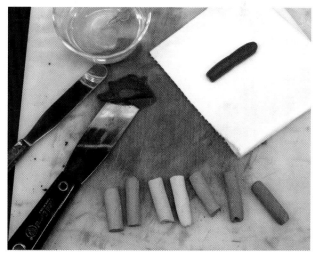

THE FINISHED PRODUCT
Here is some mixed paste, the formed pastel stick (on the paper towel), and an example of finished dry leftover pastels.

Pastel Dust **Safety**

By its very nature pastel is a dusty medium. Depending on the brand of pastel you work with and the surface you choose to apply it to, dust can be minor or heavy. Harder, less toothy surfaces tend to produce more dust, while sanded surfaces tend to hold more of the pastel particles. These minute pastel fragments are often toxic and can be hazardous to your health. Here are a few healthy habits to practice to avoid inhaling the pigment particles:

- Work with your paintings in an upright position, allowing the dust to settle gently to the bottom of the painting.
- Work in a well-ventilated studio workspace; cross ventilation is very helpful if a mechanical means of pulling air away from the easel is not utilized.
- Use a damp towel to clean up around the painting area. A damp towel will hold the dust instead of stirring it up. This is also useful for wiping your hands frequently while painting.
- Avoid the bad habit of blowing on the pastel to dislodge the dust. This removes the pastel that has not been well adhered to the surface but also makes it airborne. If you must blow, take it outside and immediately stand back.
- To better collect the dust below your painting, create a trough, something to hold the dust until it can be dealt with. Otherwise dust will fall down onto your workspace, creating a considerable mess.
- If you plan on disposing of the dust at the end of the painting, wide strips of tape with the sticky side facing up can catch the dust, making cleanup very convenient. If you want to collect the dust, a hard trough is more suitable.
- Experiment to find what works best for your needs, then get into the habit of using good dust hygiene.

COLLECT DUST WITH A METAL TROUGH

In my studio, I use a formed metal trough that runs across the bottom lip of the easel tray. This collects the dust that I carefully scrape into a container. When traveling or working on location, I use aluminum foil. It is easily folded and stored in a plastic zippered sandwich bag, taking up no room in my travel case. To attach the aluminum or reverse-tape trough to your painting surface, adhere it to the back and fold it to the front. If tape is used for the trough make sure the sticky side faces up. Often a folded strip of mat board is useful, making the trough more rigid.

Protecting and Transporting Unframed Pastels

Due to the fragile nature of pastel, it's important to employ extra caution when storing and transporting paintings—either home from a day of painting or to the framer. One method is to attach the pastel surface to a drawing board support that's larger than the painting, and cover the pastel side with glassine paper for protection. Glassine is the barrier of choice due to its anti-static nature. When it's removed, minimal amounts of pastel are affected, leaving no noticeable alteration of the painting. If glassine is hard to obtain, tracing paper can be substituted (most retail art supply stores carry tablets of various sizes). Some artists, when traveling, transport their paintings between the pages of tracing paper within the tablet. Avoid plastic as a protective layer; it has a high static charge and tends to pull considerable pastel off the surface.

Transporting Paintings

When working on location, a wet panel box is great for transporting paintings. These hold the drawing boards that the paper is adhered to, allowing for travel with multiple supports and ready to employ in an instant. My cases and drawing boards are 16" × 20" (41cm × 51cm) and 18" × 24" (46cm × 61cm). They hold 6 panels each and are stored in the rear of my vehicle, providing easy access. If you work on rigid panels like Ampersand Pastelbord or Richeson's pastel panels, you can acquire a case specific to the size of the panel. For information on transporting pastels on a flight, see page 96.

Long-Term Storage

Place unframed paintings that require long-term storage in large flat files with glassine protecting the pastel surface. Or, sandwich them together and place in archival photo boxes (available at professional photo supply stores). I like to reassess these stored paintings once a year, destroying some and reworking others. Having a secure system for preserving the paintings allows for them to be as fresh as the day they were set aside, even if I am not!

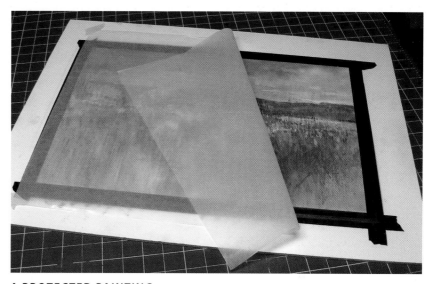

A PROTECTED PAINTING
Pastel painting protected by glassine.

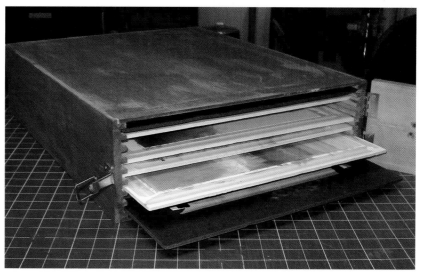

WET PANEL BOX
A case transporting pastels painted on location.

Pastel Paper, Sizing and **Ground**

When beginning a pastel painting, choosing the support (i.e., paper) on which you place the ground is your first important decision. History has shown the problems that result from using acidic products. Make sure the support you choose is of the highest quality. You should opt for a good pH-balanced, buffered paper, or better yet, 100 percent cotton fiber rag. Watercolor paper, a readily available favorite, comes in different textures, such as rough, cold-pressed, and hot-pressed. Fine printmaker's papers are also a popular choice. Many artists use Gator board, which appears strong and lightweight. Be advised, however, that Gator board is not acid-free. Its outer layers contain wood fibers; the center is Styrofoam, therefore it must be sized before you apply a ground. Also, Gator board is brittle; it can snap if dropped or bumped.

When I'm doing a large work, my preference is 100 percent rag paper or board. Museum board, rag mat board and watercolor rag boards are good, rigid surfaces. If you're concerned about weight, try preparing 300-lb. (640 gsm) watercolor paper with your ground of choice and use acid-free foam core as the backing. If I opt for a rigid board (such as Masonite), I make sure to seal it with a good sizing product before applying the ground.

The Importance of Sizing

Sizing acts as a barrier between the support and the ground. It's necessary if you are working on an acidic support to stop the migration of acid between the support and the ground. I recommend PVA Size (polyvinyl acetate) by Gamblin Artist's Oil Colors. An often-asked question in my workshops is "Why size if I am going to use a good acrylic binder in my ground?" The reason is simple: As soon as you add inert products such as marble dust and

pumice powder—to add grit and tooth to the ground—you interfere with the sealing properties of the acrylic binder. Since the binder becomes porous, it could, over time, allow the migration of corrosive acids that would come from hardboard products made with wood pulp or other wooden supports. Corrosive acids also could come from the underpainting, if it were in oil or pastel diluted with solvents, and damage the underlying support.

The Basics of the Ground

The ground is the outer layer to which the pastel adheres. It usually comprises two elements: the grit that adds the tooth and the binder that holds it together. Additional components include a thinning agent and a pigment to color the mixture. The grit I use is fine pumice powder, available at most hardware and paint stores, and marble dust (calcium carbonate), available at art supply stores. Acrylic products are the best binders available. They adhere well and retain flexibility, which allows the finished ground and the eventual pastel painting to flex without compromising adhesion. Two of the most popular products available are acrylic gesso and acrylic gel medium.

The main difference between the acrylic gesso and the acrylic gel medium ground is that the gesso contains marble dust and white pigment, so less grit is needed to achieve a desirable tooth. In addition, the white base makes it easy to add a tint in order to achieve a soft color. Remember that acrylic gel medium is simply a binder—the grit and any color tinting have to be added. Acrylic gesso and acrylic gel each has its advantage: Gesso as the binder yields a nice white base on which to develop an underpainting; gel medium as the binder allows the support to show through and thus makes the mixing of darker-toned grounds

easier. Coloring these mixes can be done with ordinary artist's-grade acrylic paint.

Golden Artist Colors offers a wide range of products. I recommend the gloss version of acrylic gel because it contains fewer by-products. Also note that many major art supply companies such as Wallis, Sennelier, Art Spectrum, Golden, Schmincke, Ampersand and Diane Townsend are marketing pastel grounds and prepared papers.

Beware of Dyes

Today's paper manufacturers produce surfaces in a variety of colors. Be cautious until you know what pigments are used to create the color and the value. Many popular papers—some that have been around for a long time—are colored with dyes that are susceptible to fading.

Most manufacturers that make a gritty or sanded surface employ high-quality artist-grade pigments, whereas those making regular paper surfaces use dyes. A little research now could save your works from being displayed in a dimly lit room in the future.

Add Color Yourself

One option is to color the surface yourself with artist-grade paint. When I want to work on a solid-toned paper, I lightly color my white grit or sanded surface with watercolor. Just remember not to overfill the tooth. When I want a plain paper surface, I use hot-pressed watercolor paper or a good, rag printmaker's paper such as Rives BFK; I then color the surface with watercolor. If you want to try something other than watercolor, I recommend gouache and liquid pure pigment. Avoid using acrylic and oil paints on plain paper surfaces. Acrylics contain a plastic film, and oils can have a corrosive effect.

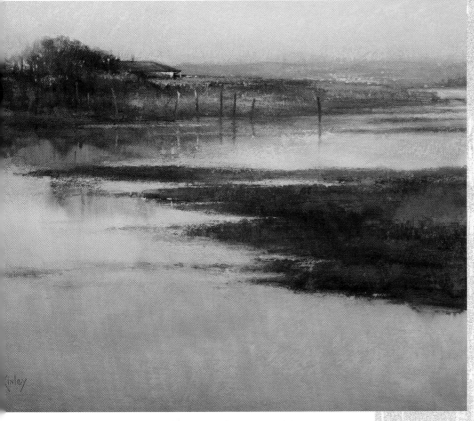

Opal Evening, 16" × 20" (41cm × 51cm)

PAINTING ON HOMEMADE GRIT BOARD

Wanting more texture, I prepared a finely woven canvas appearance with gesso and grit. When I applied the mixture with a large brush, I allowed the brushstrokes to remain visible. Then I painted an underpainting in watercolor—wet, runny and dark—that allowed the subsequently applied pastel to sparkle.

Recipes for Ground

Experiment with these ground recipes to see what works best for the result you desire. These proportions are merely guidelines. More grit adds tooth; less grit makes the surface smoother. More water allows you to even out the brushstrokes; less water allows you to make more emphatic brushstrokes.

Simple Grit Mixture No. 1
- 1 cup (250ml) acrylic gesso
- ¼ cup (50ml) fine pumice powder or marble dust
- ¼ cup (50ml) water

Simple Grit Mixture No. 2
- 1 cup (250ml) acrylic gel medium
- ⅓ cup (75ml) fine pumice powder or marble dust
- ¼ (50ml) cup water

Mix binder, water and pumice together, carefully breaking up any chunks. You can adjust the amount of pumice to suit your textural needs. Use a 1- to 3-inch (25mm to 75mm) brush to apply mixture to the board. Keep excess mixture in a closed container.

Mounting a Painting

One of the most frequently asked questions is about mounting pastel paper—especially Wallis pastel paper—to a support before painting, and whether or not this has to be done professionally. The purpose of having paper mounted is to add stability and to facilitate the use of water-based underpaintings. When deciding whether to do it ourselves or whether to have it done professionally, we must consider cost vs. archival standards.

Dry-Mounting

Expense is always a concern, especially when we're experimenting and going through a lot of paper, but certain techniques simply require the use of mounted paper. In addition, mounted paper is easier to deal with when framing and looks more professional when presented to the public. If your technique of applying pastel is "stroke"-driven, vs. the tactile "swipe," pre-mounting and having the paper perfectly flat is not as important. Artist Kitty Wallis, the originator of the Wallis pastel paper, explains a simple procedure of tacking down the four corners in the literature provided with Wallis paper. That may be all that's necessary to provide a flat enough surface for a stroke-driven pastel technique. Contact your Wallis paper supplier and ask for the Wallis paper user's guide.

If, however, you plan to employ a water-based underpainting and require a perfectly smooth surface, you'll need to pre-mount the paper before painting. When mounting paper, the main concerns are the longevity of the painting and the ability for future restoration procedures to be performed, if needed. For these reasons, my preference is the professional heat-press method, utilizing archival adhesive tissue and 100 percent rag museum board as the support. This requires professional equipment and a bit of training, but is the standard utilized by professional photographers for decades and recognized as the most secure.

Pre-Mounted Paper

With the popularity of various underpainting techniques on the rise within the pastel community, many of the major pastel distributors offer pre-mounted pastel paper. The paper is generally mounted to an archival surface. Some flush-mount the surface to the edge, requiring no trimming in advance of framing, while others leave a border around the paper, making it easy to attach to a drawing board. Whichever you prefer, the benefit of being able to purchase a pastel support that is less prone to wrinkling when a wet technique is employed is a pleasure. Check with your favorite pastel retailer for availability.

Wet-Mounting Using pH-Neutral Adhesives

Mounting pastel paper to a strong backing board is something that most artists can accomplish on their own if they spend some time practicing and acquire the proper materials. The process can be messy, so it's best to allocate a day or two to the task—preparing the required materials and then mounting as many surfaces as possible.

Since the glue used is moist, the process is referred to as "wet-mounting" and is not considered as archival as the dry-mount. While the dry-mount method is reversible with the application of heat, the wet-mount method requires water or other solvents (depending on the glue) to be reversed. Since a pastel painting could easily be damaged with the application of a wet product, it becomes nearly impossible to reverse the mounting process, producing a permanent outcome. For this reason it's of the utmost importance to utilize the highest archival standards possible.

For the substrate, I recommend 100 percent rag museum board because of its porous surface, which has a better chance of bonding to the adhesive. Avoid foam board, even if it's acid-free, as it's easily dented and damaged. If you choose to use another surface, check its pH and acid content before proceeding.

For the adhesive, you'll need a glue that's pH neutral and acid-free to prevent corrosion. Two adhesives I have used with success are VacuGlue 300, from Seal Products, and Neutral pH Adhesive, a Lineco Inc. product. Both are reversible with water. I'm aware of other artists who use acrylic gloss medium which, once dry, is impervious to water. With acrylic medium, you must work quickly to get a good bond before it has a chance to dry. Note: With heavy water-based underpaintings, you should limit the amount of moisture placed on the surface. This is especially crucial around the edges, which easily wick water, releasing the bond. Otherwise, an adhesive that is not water-soluble (like acrylic painting medium) may be the best choice.

The procedure works this way: Cut the pastel paper to the desired painting size and the mounting board a little larger; this allows for positioning without being overly precise. The border makes for easier handling and attachment to a rigid support, adding stability. The excess border may be removed with a sharp craft knife after the painting is complete. Place the pastel paper upside down on a disposable surface like newsprint (which needs to be discarded after every preparation to prevent glue contamination of the painting surface). Apply the adhesive liberally to the back of the paper with a brush. Keep this application

as wet as possible until the paper is adhered to the mounting board; otherwise, a good adhesion may not occur. Carefully flip it over and position it on the mounting board, applying gentle pressure to the center and then working your way out toward the edges. If glue seeps along the edge, quickly wipe it away from the pastel paper so that it doesn't affect the pastel surface. A rubber printmaker's brayer or similar device can be handy for this part (make sure no glue gets on the surface of the roller). Lay the mounted paper on a hard, flat surface and apply weight; I use a large, smooth sheet of hardboard with gallon cans of paint placed on top to add weight. When doing multiples, stack one on top of the other and leave to dry overnight. The next day, they should be ready to use. If curling occurs due to shrinkage of the adhesive, tape the mounted paper to a drawing board before painting. When completed, framing should keep it flat. If curling is severe, flip the mounted board over and apply a coat of acrylic gesso or similar acrylic product to the back. When it dries, the board should be considerably flatter.

No matter which mounting method you prefer, what is of the utmost importance is to create an archival surface by utilizing acid-free, pH-balanced products. A lot of money can be saved by mounting pastel paper ourselves, but it does impose on precious painting time. Allow for experimentation with the process before producing that masterpiece. With practice you'll have it down to a science and reap the benefits of a perfectly flat, rigid surface.

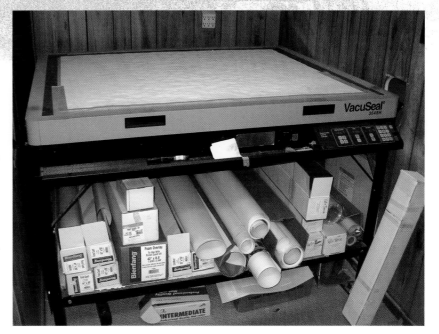

VACUUM HEAT PRESS FOR DRY-MOUNTING
For water-based underpaintings, I use a large, professional vacuum heat press to achieve a perfectly smooth surface.

Photo courtesy of Central Art Supply

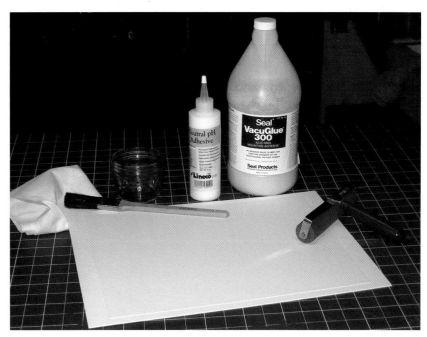

TOOLS FOR WET-MOUNTING
From left to right: clean rag, Wallis pastel paper, rag board, brush, jar, pH neutral adhesives and rubber brayer.

Fixative

Pastel is one of the few painting mediums that never dries. Since it never forms its own protective outer layer, it's always susceptible to alteration or damage if mishandled. This vulnerability has led painters to fixatives as a way to increase a pastel painting's stability.

When applied to works in pastel, pencil, charcoal or chalk, fixatives can effectively reduce smearing and smudging. For fixatives to be useful, they should be non-acidic and non-yellowing. Fixatives aren't meant to be a varnish in the traditional sense of oil and acrylic painting, so they don't replace the need for glass when framed. Pastel paintings, even those treated with fixatives, still need the protection that glass affords.

Applying Fixative

Basically, there are two types of commercial fixatives available: workable fixative, which has a light consistency that facilitates additional pastel application; and final fixative, which is heavier and used only at a painting's completion.

It's best to apply spray fixatives in multiple, thin coats rather than one heavy coat to avoid oversaturating the pigment. Allow each to set up before applying the next. Don't be too eager to create a rock-hard layer; this can be achieved but is best accomplished with multiple thin layers. A single heavy application can create a finish similar to varnish and actually eliminate the tooth, preventing the application of subsequent pastel.

Always test the spray before aiming it toward the painting. Nozzles can become clogged and spit globs of fixative, which can create a greater problem than the one you're repairing.

Fixative as a Technique

Some artists use a fixative as part of their technique: They deliberately create hard layers of pastel and then apply subsequent pigment. I use fixative in light to moderate applications only in areas that need to be reworked. By standing back and slowly moving toward the painting, I can control the application. Sometimes I lay the painting

flat and gently put sheets of glassine or paper towels around the area to be sprayed. This prevents the fixative from affecting the areas that I am pleased with and allows me to direct the product only to the area in need.

The Fixative Debate

There are, among pastelists, some passionately held opinions about the use of fixative. One position is that every finished pastel painting should have a final application of fixative to add stability and protection to the surface, whether or not fixative was used as part of the painting process. Others adamantly adhere to a policy of no fixative at all at any point, citing the potential for the alteration of a pastel's appearance. Still others opt to use fixative in their painting process, but then skip a final fixative application to avoid this shift at the conclusion of a painting.

Even if your intentions are to paint without fixatives, it's still beneficial to familiarize yourself with the products. Experiment enough to see how fixative can be used effectively for the building of layers of pastel.

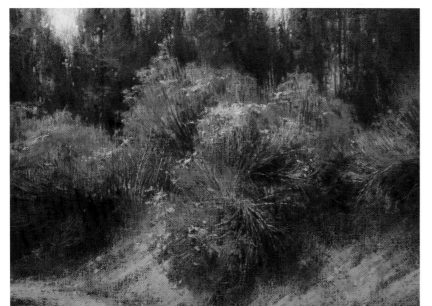

LAYERING

In my painting *Saffron Crowns*, I built up layers of pastel and fixative. The detail above illustrates the appearance of the pastel with fixative in use.

Saffron Crowns, 16" × 20" (41cm × 51cm)

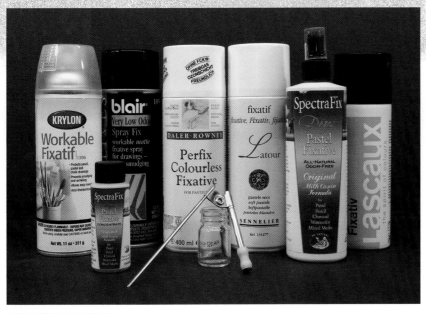

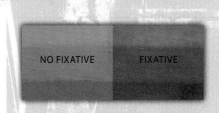

Fixatives Dull & Darken

A certain amount of darkening and a slight sinking of the surface appearance will occur with the use of fixative, but this often dissipates after drying. If you plan to apply subsequent layers of pastel to a painting, develop a plan in advance for the inevitable color and contrast shift, even if subtle. It's a prerequisite.

FIXATIVE BRANDS

Fixative brands vary and react differently, depending on the make of pastel and the surface being used. Experiment with a few before committing to one. Be sure to read the directions supplied with any fixative product. Holding the spray can too close to the artwork, for instance, or applying the product too heavily can drastically alter the pastel's appearance. From left to right:

- **Krylon Workable Fixatif**—This is a popular, inexpensive resin-based workable fixative. It's non-acidic and good for creating additional tooth on an overworked surface. It has a tendency to darken and sink the appearance of pastel, so this should be anticipated.
- **SpectraFix Degas Pastel Fixative Concentrate**—This casein-based fixative is based on an antique French recipe used by Edgar Degas. Non-toxic and archival, the concentrate is to be diluted with pure grain alcohol, which makes it travel-friendly; you can carry the concentrate undiluted and purchase the alcohol to mix on location.
- **Blair Spray Fix**—Blair's workable matte fixative is similar to Krylon Workable Fixatif but is low-odor. Because it tends to darken and sink the appearance of pastel more than other brands, I recommend testing it in advance, using light applications.

- **Daler-Rowney Perfix Colourless Fixative**—This English-made, resin-based fixative has little effect on the appearance of pastel. For this reason, it's a favorite among many professional pastel painters and is a mainstay in my studio. It's well-suited for pastel techniques requiring layers.
- **Sennelier Latour Fixatif**—This French-made product, which carries one of the most historic names in pastel manufacturing, is a high-quality, resin-based fixative for soft pastel. Latour Fixatif has minimal effect on the appearance of pastel and is comparable to Daler-Rowney Perfix, making it equally popular among pastelists.
- **SpectraFix Degas Pastel Fixative**—This is the same casein-based fixative as the concentrate but diluted and packaged in a pump bottle for easy, eco-friendly application. Whereas aerosol fixatives need to be taken outside for safe application, this pump bottle fixative can safely be applied in your studio without concern.
- **Lascaux Fixativ**—This Swiss-made fixative is acrylic-based and most suitable as a final fixative. Creating very little color shift and highly archival, this is a favorite for final fixative protection at completion of a painting. Because it's acrylic-based, it isn't well-suited for many layers of pastel, especially if heavily applied.

Re-create Lost Surface Tooth with Fixative

With each application of pastel, surface tooth can easily be lost, making subsequent layers difficult, if not impossible, to apply. When this happens, gently apply a light application of workable fixative after the initial layer of pastel to create additional surface tooth. Depending on the abrasiveness of the surface, the relative hardness of the pastel stick and the volume of pastel already applied, this can have a profound effect, making subsequent pastel layers considerably easier to apply.

Working With Photo **References**

As worthwhile as it is to work from life, whether from a live model or on location, there are times when it simply isn't practical. For these occasions, photography is an indispensable tool for artists, providing an image that can spark memories and transport them back to the scene of their initial inspiration.

Photography allows users to record a variety of situations instantaneously, providing artists the chance to broaden their horizons. In the same amount of time that would be spent doing a single sketch, an artist can record hundreds of reference photos, creating enough information for a year of painting.

Photography's Biases

When artists use photography without understanding its biases, they risk making paintings that are subordinate to the photograph—merely duplicating the photo's limitations. Four visual perceptions that photography can easily misrepresent are depth, edges, contrast and color. By understanding the nature of these limitations, a painter will be better able to harness the power of photography and make wiser choices when taking reference photos.

Dealing With Depth

Depth perception is one way that photography's descriptive powers can fall short. To deal with the issue, one option is to take the first reference photo with the camera lens set to match human depth perception. For standard digital cameras, this is close to 28mm. On a 35mm film camera, it's 35mm. If your simple point-and-shoot camera doesn't indicate these settings, just bump it up one telephoto notch when the camera is turned on. When initially powered up, most automatic cameras start at a mild, wide-angle setting. After framing the scene and taking this first photo, you can zoom to telephoto or back up to wide-angle as desired, recording any pertinent information you wish, but relying on the first photo to relay the depth as it was perceived on site. This photo allows you to place your feet back on the ground, no matter what was done with subsequent exposures. It's the most important reference photo.

Telephoto settings are useful for pulling objects closer and making them appear larger, but they greatly distort the spatial depth by closing space. Severe wide-angle settings produce a panoramic view, allowing more of the scene to be included in a single photo. This creates more distance between objects, and opens up space. For sweeping panoramas, therefore, it's often better to take a series of photographs, while slowly turning. These can be stitched together digitally or simply taped together for reference, providing a more accurate record of object relationships in the scene.

On the Edges

In terms of edges—that is, the sharpness or softness of the transitions between objects—they may appear soft or sharp in a photo, depending on the focus point and aperture of the exposure. A small, narrow aperture (camera f-stop) expands focal depth; a large, wide aperture—on the other hand—contracts, centering sharp focus on one plane and making everything in front of it, and behind it, appear out of focus and fuzzy.

As useful as these lens and exposure settings might be, it's imperative to consider the distorted appearance they produce.

Capturing Contrast

Value, or the reflective quality of surfaces relative to illumination, is possibly the area in which a camera's limitations are most noticeable. With the camera, value ranges are often condensed, leading to excessively dark shadows and blown-out highlights. The human eye, however, is capable of perceiving 15 to 25 value separations. Photography, at its best, averages between 5 and 10. It's common for photographs to be exposed for the light, creating shadowed areas that appear completely black. When exposed for the shadow, lights condense into total white, lacking any detail.

It's possible to combat this limitation by manipulating values both in camera settings and in processing. High Dynamic Range (HDR) manipulation has become a very popular in-computer means of broadening the value range of photographs. Photomatix Pro, a downloadable software from HDR Soft (www.hdrsoft.com), and Adobe Photoshop (www.adobe.com) are two options for HDR manipulation. If you're fairly computer savvy, learning this process will be helpful for producing images that depict a wider range of values—more in line with what's seen by the human eye.

Another method for expanding the value range and detail of high-contrast scenes, such as landscapes with a highly illuminated sky, is to use a graduated (or split) neutral density filter. The filter attaches to the threaded outer lens of most SLR-style cameras (which have interchangeable lenses) and high-end digital cameras. The filter is free floating. By rotating the darker, graduated portion over the highly illuminated portion of the scene, more detail and contrast is produced. If you'd rather skip the filter, there are Photoshop applications that use masks to replicate the effect of a split neutral density filter.

Another popular photographic filter is the polarizer. This filter refracts the reflected light entering the lens, often removing excessive glare. The sky becomes darker and a deeper shade of blue, and water surfaces lose reflection, providing you with the ability to see in to the depths. Fields and trees lose reflected atmospheric light, becoming rich in color.

As appealing as this can be photographically, a painter should take care. Often these reflective tendencies become a major component of the painting, and if your desire is to accurately portray the scene, these altered photographs can interfere.

Considering Color

When analyzing the color in a photograph, remember that it's only a suggestion of reality. What's represented often has very little relationship to the true color temperature of natural light. Learning to adjust the white balance setting of your digital camera is extremely useful. For most situations, the automatic white balance setting will suffice. In unusual lighting conditions, however, setting the white balance manually for a specific type of lighting—such as overcast, tungsten or florescent—can be helpful.

For even greater accuracy, a custom reading taken from a neutral surface, such as a photographer's gray card, can prove invaluable. Refer to your camera's owner's manual for additional information on custom white balance settings.

These color temperature shifts can also be adjusted with image processing software on the computer, but it's always best to start with the most accurate image possible before attempting to make adjustments.

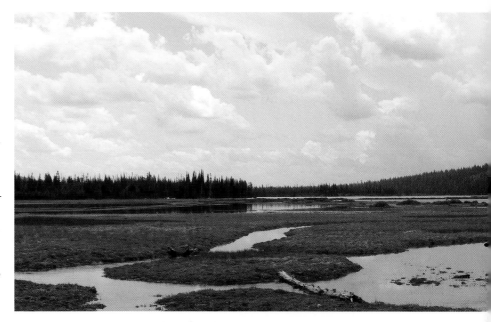

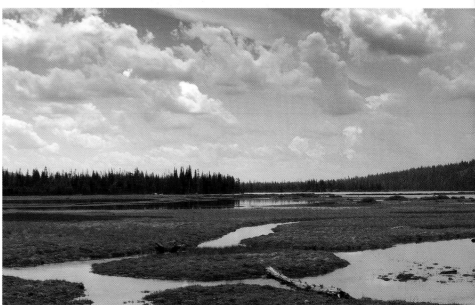

USE A FILTER TO ALTER CONTRAST

These photos of Sparks Lake in Bend, Oregon, illustrate how the use of a graduated neutral density filter can impact contrast. Note the difference between the sky in the plain exposure top vs. the bottom photo, for which the filter was applied.

Since color is so subjective—no two of us see it the same way—it can be quite helpful to convert images to "gray scale," a form of digital black-and-white. The photo reference provides the detailed information of shape, depth and form without influencing color selections. Many artists create work directly from these monochromatic references.

Digital Photography

For the purposes of creating reference, digital photography has become the dominant player. It's more versatile than film, providing almost instantaneous imagery and an array of display possibilities. Images can be recorded without any thought to the expense of film and processing, and—thanks to in-camera review—digital photography even allows for the instant deletion of unwanted images. Media cards, which store the digital images, can be loaded into a computer for adjustment and long-term storage, or the media can be directly transferred to a printer, bypassing the computer altogether.

Digital image files can be processed into prints by means of a personal printer or commercial processor. Keep in mind that ink and paper have associated costs. When printing large quantities, it can be more cost-effective to use a commercial lab.

Burn a backup CD or DVD of your image files for safe storage. If something happens to the computer, it can be replaced, but you'll never be in that exact place and lighting situation again. Label the files and discs for easy recognition, making note of the date and location of the images.

In terms of camera selection, decide whether your primary use will be reference work. If so, a simple point-and-shoot model may work best, allowing for ease of travel. Professional requirements like high-resolution images, which are suitable for publication, may require more substantial equipment.

No Substitute for Observation

Overcoming photographic challenges requires continued analysis of how we see in comparison to the camera. It's important to be aware of the limitations and stay sensitive to human perception, which is best learned by spending time in observation—not just a quick glance, but studied quiet time. It's from these interactions that a better relationship can be formed; personal aesthetics develop, leading to individual expression.

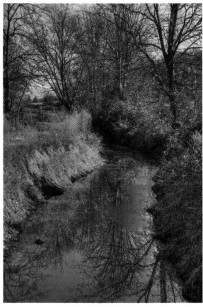

HDR MANIPULATION: CANAL

These photos of a canal in the Rogue Valley of Oregon demonstrate how an image can be altered on the computer using HDR (High Dynamic Range) manipulation. Notice how the HDR alteration (on the right) includes more detail and information in the dark shadow and highlight areas.

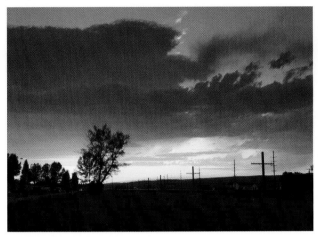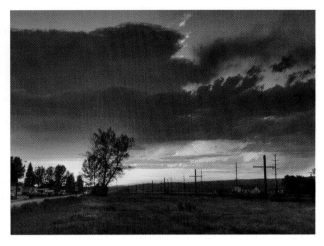

HDR MANIPULATION: SUNSET

This sunset from Bozeman, Montana illustrates how detail is lost in extreme lighting situations like sunsets. Standing there, I could see detail in the earth as well as the sky. Combining three exposures with HDR manipulation allows for a wider value range providing that value detail but may produce overly saturated colors that are not realistic and should be downplayed.

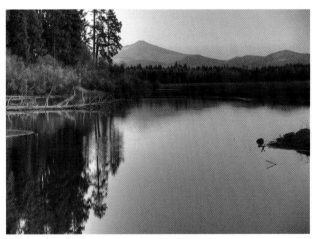

HDR MANIPULATION: TWILIGHT

Twilight is an intriguing time of day. Due to the limited amount of time it provides, painting en plein air can be difficult. When used for reference, standard photography will produce lackluster results that rarely represent how the scene appeared. HDR manipulation helps produce images that close the value gap between the soft light falling on the earth and the highly illuminated glow of the sky.

Composition

McKinley

Last Light Waterlands
12" × 16" (30cm × 41cm)

Basic **Elements** of a Painting

Before diving into the world of pastel, it helps to understand the basic elements that make up a painting. These are the nuts-and-bolts elements that guide your choices before starting, during application, and in resolution at the end of a pastel painting.

Initial Concept

While involved in a painting, it's easy to get caught up in the moment and lose sight of your initial purpose. If you find yourself straying from your initial goal, ask yourself what the original concept was: Why did you decide to paint the subject in the first place? By revisiting your original idea, you'll be better able to evaluate the painting and see where you went astray.

Drawing

Strong drawing is the foundation upon which a successful pastel is built. Check to make sure that the basic design is sound. Composition, linear perspective and proportion are some of the major factors that may require re-working.

Compositional Integrity

If the painting is unbalanced and lacking a pleasing aesthetic, changes are in order. Step back and look at the composition of the painting. Ask yourself if the objects in the scene work together to lead the viewer to the center of interest, or if they impede that effect. At times this entails the addition or subtraction of objects, values or colors. Often when analyzing composition, we focus on just the objects, ignoring the placement of the major value and color relationships. The abstract masses of value and color are of equal importance as the outline of the objects. Changing the value relationships or color sense can correct the way a painting reads. Giving

yourself permission to make changes can strengthen the overall content and better convey your concept.

Linear Perspective and Scale

You may need to make corrections to the angles and proportions of objects so that a proper sense of their relationships are communicated to the viewer. A basic understanding of linear perspective is something every serious artist must acquire. Where is the eye level in the painting, and what is the relationship of the objects to it? Sometimes, simple angle corrections can make the whole painting come together.

Proportion refers to the relative width and height of things. If they're misrepresented, the painting will look distorted. Measure and compare distances in the scene and strive for the same comparative ratio within the painting.

Value

The concept of value refers to the relative lightness or darkness in a painting. The intensity of the light, its angle to the surfaces represented and their reflective quality are all part of the analysis. By using a scale from white to black, we can learn to see value more accurately.

When viewing your work, ask: Are the relationships of the major value masses correct or in need of adjustment? Is the value modeling within those masses accurate or overemphasized? We often exaggerate the value masses—getting the highlight too light and the shadow too dark. Just because we see light or shadow within a mass doesn't mean it has to be white or black. It's easy to get carried away if you're not looking at the big picture. To understand values, you need to see relatively: Break the painting into three or

four abstract value masses without thinking about the objects. By looking at the painting's value masses instead of at one specific area, you can better see how the general objects relate.

Color

Each object in the painting may have a different base color, but they all share one thing—light. You must be sensitive to the temperature of the light and unify it with the individual elements in the painting. In the natural landscape, early morning and evening generally have the warmest temperature bias, with midday being the most neutral. Weather conditions also have a profound effect on the color temperature of the light. Learn to be sensitive to these tendencies through observation. Look at your painting to see if there is a sense of shared color temperature. Do the colors work together to communicate the general temperature of the light, or are they disconnected and fighting for individual attention?

Color Harmony

Color harmony is derived from the individual elements' sharing the common thread of light. Minor temperature adjustments can make a huge difference in how colors relate, creating a holistic harmony in a painting. Are there too many colors vying for dominance? By uniting individual colors with others and allowing a few to stand out, the overall color harmony will be greatly improved.

Edges

Edge refers to how we handle the outer borders of individual objects. Because of the physical placement of our eyes, we are better able to perceive depth when looking

at objects that have bulk. Things in the physical world have a beginning and an end, which create natural stopping points, but the artist can manipulate these perceptions by learning to control the edges of the objects in the painting thereby creating depth and mystery.

A study of your painting will reveal whether there is variety in the use of edges, or whether they are all the same. If all of the edges are handled in the same way, the painting will lack depth. Varying the edges not only creates depth but also draws the viewer to the areas of importance. It's easy to strengthen edges as a painting progresses, so try leaving them as soft as possible in the beginning, then finish with those few strong edges that demand attention.

Aerial Perspective

Although we work on a flat, two-dimensional surface, we attempt to create space. That feeling of air and dimension in a painting is its aerial perspective. The tools of aerial perspective are value, color and edge.

Does the painting have good depth, or would the manipulation of the components of aerial perspective strengthen and create resolve? Are similar objects cooler in temperature as they recede? Are the values and the edges handled in such a way—lighter and softer—to relate the depth of the scene? If not, making minor adjustments could pull the painting together.

Watch Richard demonstrate the three stages to a successful painting. Visit **http:// mckinleyvideo1.artistsnetwork.com**.

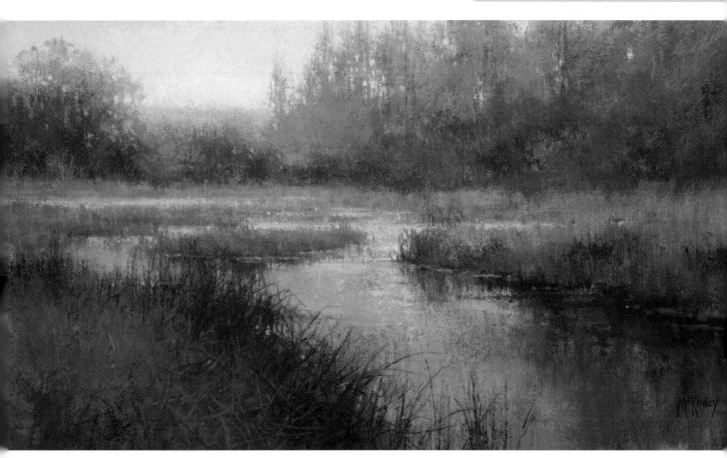

My Evening Place, 13" × 24" (33cm × 61cm)

Seeing and **Observing**

Most paintings, no matter how imaginative, come from something an artist has actually seen. From the moment babies open their eyes, their minds store visual information and, over time, these visual impressions can become very symbolic. People mentally identify outlines and forms, associating them with things they know. Unless artists discipline themselves to really see, they'll paint only what's in their minds.

Because the mind works in a symbolic way, a painter must learn to observe with the innocence of a small child. Think of the age when everything is new and a child is constantly asking, "What is that?" As an artist, you want to return to a time when you were filled with that kind of wonder. If you do, you'll begin to truly perceive what lies before you. That's when you'll feel ready to place the pastel to the surface and make a personal statement for others to experience.

Seeing Abstract Shapes

When starting a painting, it's best to begin with a few simple elements before proceeding to the more detailed components. We need to see the abstract elements of the scene—consisting of shape, value and color in their simplest forms—before focusing on the intricate details and accents.

One way to see this more easily is to look at your subject matter upside down. If you're using a reference photo, turn it upside down and block in the beginning masses. If you're working directly from life, use a mirror: Position it on your forehead, look up into it, tilting it to the proper angle to reflect the scene in front of you. By turning the world upside down, you deny the mind information it commonly recognizes and understands.

We all have visual bias. The eye transmits information to the mind, and it associates what it knows to those visual symbols. Over the years, prejudices are formed and we no longer see things as innocently as we would hope. Looking at a scene upside down tricks the mind and enables us to more easily see the scene abstractly and objectively.

Squinting

Another way to diminish details is to close one eye and squint with the other. This blurs the vision, allowing less detail to be seen. As the minute elements of the scene are blurred, they appear to blend together, making it easier to see the general value and color mass of a given area. This squinting technique is not only useful for seeing a scene more simply, but it also allows us to assess our painting as if we were a greater distance away.

As you break down a scene into abstract shapes, try to limit the number of large shapes to no more than five. More than that becomes too complex, often leading to a disjointed patchwork of shapes that lack cohesion.

As you squint at things upside down, look for major value and color separations and let these define the large shapes. Don't become overly picky; it's okay to generalize, to find an average. Disregard the minuscule and focus on the large. These shapes should share a common value and color sense. Remember that this isn't about individual, recognizable objects. These shapes should appear abstract in nature. As the painting progresses, details and accents will be added, ultimately producing a recognizable representation of what you're painting.

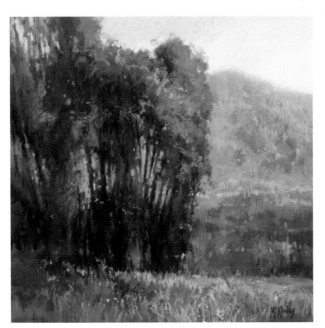

INITIAL PENCIL
SKETCH

SIMPLE OUTLINE
DRAWING

4-VALUE SKETCH
IN MARKER PEN

UNDERSTAND A SCENE'S SHAPES AND VALUE MASSES
Before painting, create value thumbnail sketches to break a scene into strong shapes and value masses. These elements are the foundation of a good design and the backbone of a successful painting.

Standing Guard, 12" × 12" (30cm × 30cm)

Planning a Composition With **Thumbnails**

Just like a house needs a solid foundation for support, so too does a successful painting. One of the best ways of insuring this is to focus on composition and design elements prior to applying pastel to the surface.

As painters, we are often reminded that the ability to draw is essential to a successful painting. Being able to accurately render the appearance of things is crucial to capturing a likeness. But composition entails more than that ability. It encompasses the arrangement of simplified shapes, angles of visual direction, value masses, and color choices throughout the framework of the painting. Just like the author arranges words and the musician arranges sound, the painter arranges visual elements to communicate intent and reinforce their concept.

One of the best means of exploring these possibilities is to do a series of thumbnail sketches prior to painting. As the name implies, these sketches are meant to be small. Working large encourages detail—the nemesis of composition. Details tell us about things; thumbnail sketches tell us about relationships. If you are accustomed to sketching detailed renderings of scenes, this can be an awkward exercise. Give yourself permission to be messy, even crude, with these sketches. Keep them simple. Break elements of the scene into no more than four or five major shapes. Analyze the directional thrust of the shapes. Associate reflective light (value) to the shapes. Scrutinize these thumbnail sketches and make adjustments. Leave out, add, move, and alter

elements to strengthen your concept—the idea you wish to communicate about the scene. Rely on these sketches to set the foundation of the painting.

You can avoid many hours of frustration by orchestrating these compositional elements before committing time and energy to the process of painting. As the painting progresses and details are added, they provide a reminder of what was really important and help to keep you on track as you become enamored with incidentals. They become the blueprints of the structure. Remember, all the pretty pastel in the world will not support a weak design.

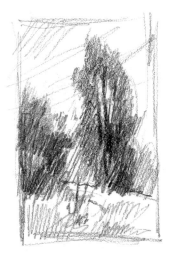

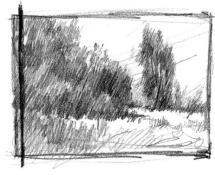

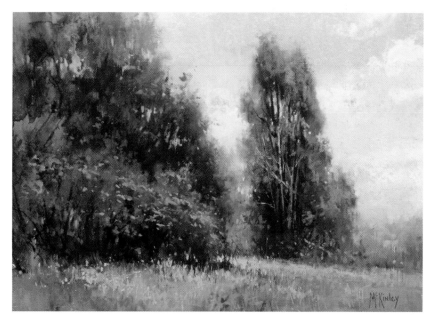

Layers of Light, 10" × 14" (25cm × 36cm)

ADJUST YOUR COMPOSITION WITH THUMBNAILS

When painting on location, thumbnail sketches help me solidify my concept and work through any problems I might confront with the makeup of the scene. After finishing the sketch for *Layers of Light*, I decided to push the design slightly to the left to create a more pleasing balance. Before painting, I also tested an alternate vertical concept; ultimately the horizontal won.

Initial **Drawings**

The amount of drawing placed on the pastel surface before painting is an individual choice. When I refer to a drawing on the pastel surface, I mean the placement of the composition—an arrangement of shapes and values. Some painters need an elaborate drawing to feel comfortable, while others place just a few marks.

Consider which surface you'll be working on and what product you'll be using to do the drawing. Depending on the surface, many products may be used—drawing pencils, vine charcoal and pastel pencils are a few of the most common. I use all three but depend on a simple 2B or HB pencil most of the time. Since the majority of my work is done on a sanded surface, such as Wallis paper, I enjoy the fluid way the pencil imparts a mark, flowing like a stick of margarine onto a warm plate.

Consider the Underpainting

If you plan to underpaint, it's best to experiment first to see how the product used for the drawing affects the outcome. Some are prone to smearing and, if applied heavily, may gray and weaken the color being applied. No matter what I use for the drawing, I blow off any loose dust. I'm not worried about losing the drawing once the underpainting begins, but I don't want to alter the appearance by having too much of the drawing materials mixing in.

Pinpoint Your Comfort Level

What will it take for you to feel comfortable before applying pastel? I utilize a series of thumbnail sketches before starting a painting, then do an involved drawing on my pastel surface. I take my time, allowing myself to become tuned in to the subject. Why spend the time only to lose it or cover it up? For me, the initial drawing acts as my warm-up and helps me slip into the painting mindset I need to paint with enthusiasm and clarity. Having physically worked through the drawing, I have internalized the elements of the scene. I realize this may be frustrating for some and a waste of time for others, but for me it is an invaluable step.

 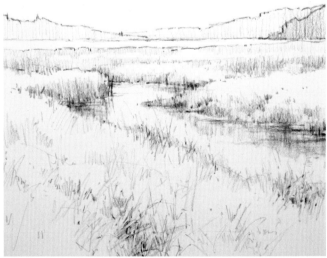

INITIAL DRAWINGS INSPIRE CONFIDENT PAINTINGS
These drawings were done on Wallis white museum-grade paper with an HB drawing pencil. To correct a misplaced stroke, I wipe it off with a chamois or strong paper towel. Although a ghost image still remains, it's easy to cover.

Center of Interest and **Focal Point**

Successful paintings often rely on a strong center of interest to communicate the intention of the painter. This is an area within the framework of the painting that holds the viewer's attention. Our eyes go there first, then visually travel around the painting, returning to the area to linger for a while longer.

The Focal Point

The center of interest (or area of interest) and focal point are commonly thought of as one in the same. The center of interest can be defined as the area of a painting that you want to stand out and be remembered—the main subject. It's here that we reveal the purpose behind the painting.

Focal point can be defined as: a place of focus; a center of activity, attraction or attention; or a point of concentration. Artist and author Greg Albert acknowledges that the center of interest and focal point should coexist in the same place, but distinguishes the two as separate ideas. He describes the center of interest as the spot that attracts the viewer's mind because it's intellectually appealing. The focal point, on the other hand, attracts the eye because it's visually appealing. For a painting to be successful, then, the center of interest should also be the focal point.

In paintings, there are certain symbolic elements that always demand attention; viewers will be drawn to them no matter where they're placed in a painting. In a portrait, for example, it's the facial features. In a landscape, it's figures, wildlife, man-made structures, letters and numbers that attract attention. Strong contrasts of edges, light and dark, and color, are also things that draw notice. If these are positioned outside the area of interest, they'll need to be manipulated and weakened in importance; otherwise, they distract the viewer.

Area of Focus

When the human eye focuses, it creates a sharp delineation between individual objects, forming a focal point. Outside this area of focus, objects become blurred and softened. Sharpened focus around the focal point affects more than just edge. It also creates a contrast of light and dark, and color clarity. This is the reason that too much detail in a painting can lead to an unnatural appearance; the viewer simply doesn't know where to look and becomes bored. It's not that everything outside of the focal point should be blurry, but it's imperative that a painter orchestrate contrast of edges, values and colors as they approach the outside edges of the painting in order to retain the viewer's attention.

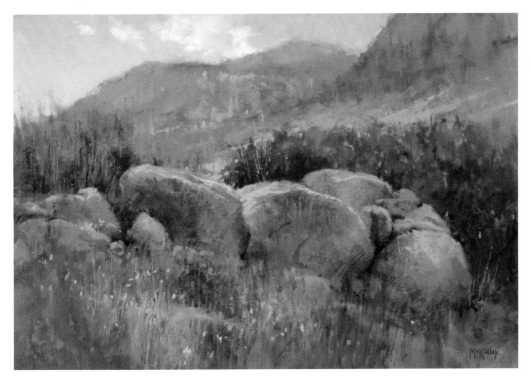

THE CENTER OF INTEREST AND FOCAL POINT SHOULD COEXIST
Here, the center of interest features both the contrasts of edges and values. Softening toward the edges of the painting strengthens the focal point's impact.

Stones of the Sandia, 12" × 18" (30cm × 46cm)

Rule of **Thirds**

There are many rules pertaining to the placement and handling of the center of interest. Representational paintings, which are filled with recognizable objects, are best handled with a strong center of interest. The rule of thirds or "divine proportion" is derived from the concept of the golden section (or golden mean), a mathematical ratio that's based on a natural aesthetic we find pleasing. Essentially, dividing a painting into thirds, both vertically and horizontally, and placing the center of interest in one of the four intersecting lines, constructs a natural, asymmetrical composition.

The other aspects of the painting should complement this placement, allowing the viewer's eye to be drawn across and around the composition, leading the eye back to this point. This can be as strong as a waterway or road leading to the center of interest, or as subtle as a repeated color or value meandering toward the area. Employing the rule of thirds means you'll never end up with the main focus of the painting at dead center, an arrangement that visually divides the painting in half.

Another useful compositional rule for orchestrating the center of interest is to make sure there's inequality among elements of the painting. Since a lesser quantity will always draw attention, make sure the center of interest has its share of the lesser quantities. If a painting is dominated by large shapes, for example, a small shape in the center of interest will draw attention. The same holds true for value and color; if a painting is dominantly dark or warm in tone, a light or cool tone will draw attention, which can therefore be effective in the area of interest.

Other tools for creating visual excitement within the center of interest are contrast of edge, contrast of value, contrast of color, direction of line, and the use of symbols (such as people and structures). Don't try to use them all. Be selective.

Each of us brings a unique perspective to our observations. Go painting with a group of friends and you'll experience this diversity of artistic spirit. Each person sees a scene differently, choosing to portray it in a distinct way. Since a painting is a statement of your making, it's important to know what about a subject caught your interest. Let that guide your compositional choices, conveying your experience of a subject to the viewer.

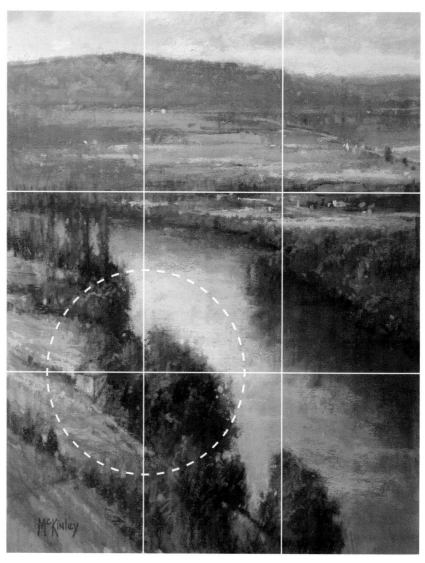

View from Belaye, 14" × 11" (36cm × 28cm)

PLACING THE CENTER OF INTEREST

In *View from Belaye,* the rule of thirds has been applied and a circle indicates the center of interest. Contrast of value in the center of interest, as well as some intense color and the presence of a building attract attention.

An Artist's **Signature**

Placing your signature on a painting is the ultimate statement of pride and ownership. Some artists choose to prominently display it for the whole world to see, while others opt for a subtle approach, making it barely visible. Like so many aspects of paintings, it's personal.

The signature is a natural part of the visual composition and should be thought of in those terms. The main things to consider are placement, size, value, color, style and content. Traditionally, the lower right-hand corner is the spot for the signature. When we read a written page, we end at the bottom right; thus this location feels like a natural end-point in Western culture. If, due to the content of the composition, this isn't a suitable location, look to the lower left, and then consider the upper right and left corners. Remember to consider the matting or frame when positioning the signature; otherwise, you may be cutting it off or setting it too close to the edge.

Size, Value and Color

The size of the signature definitely makes a statement, and moderation is recommended. You want the viewer to see and appreciate the painting before your name.

If it can be read from across the room, it might be too large. The value and color of the signature should complement the painting. I recommend choosing a value either slightly darker or lighter than the surrounding area. For the color, I prefer something neutral that pertains to the dominant color scheme of the painting. Historically, a popular color choice was red, which could be near the value of the area upon which it would rest, yet stand out and be recognized. It was especially useful for the illustrative market as red photographed darker in black and white, making it stand out when reproduced.

The style of a signature also makes an artistic comment. The two extremes are the signature as handwriting and block printed. A beautifully hand-scripted signature relates the flair of the artist it represents, just as our individual signature does. The simple block printed signature makes for an unobtrusive, easily read, statement of authenticity. I have used both, migrating to the simpler blocked style over the years. Placing your full name or just the last name is again a matter of personal choice. What is advisable is to never use just a first name or nickname. This informality lowers the viewer's respect for the piece.

Signature Tools

A few methods may be employed when signing pastels. Most of the time if there is not a heavy layer of pastel, or too dark of an area, a simple drawing pencil (2B or HB) is employed. If drawing pencils won't suffice, a pastel pencil or sharpened hard pastel can be used. Pastel pencils offer a ready tool in a variety of colors and values. Harder pastel sticks can be sharpened to a fine point facilitating easy application. Even a simple carbon pencil can do the job. If there is a heavy buildup of pastel in the area where you wish to sign your name, you might have to use a softer pastel stick. This isn't easily accomplished when a delicate aesthetic is desired. A light spray of fixative to the signature area, or a gentle scraping off of some of the pastel, may prove helpful.

Whichever style or method you choose to use for signing your pastels, do it with pride. You deserve the credit for having created something for the whole world to enjoy. Bravo!

MY PAINTING SIGNATURE

This signature was done with a soft, violet-gray pastel pencil on Wallis paper. My early signature was much more flamboyant and included my first name. It went through various incarnations as I developed and matured as a painter. Eventually, I landed on the simple elongated printed version I have used for the last twenty years

Santa Barbara Morning
10" × 14" (25cm × 36cm)

Color

Everything we're capable of seeing shares this in common: a light source. Science teaches us that sunlight is made up of all colors in the spectrum; it's the light which is not absorbed by the object that reflects back and produces the colors we see. When Sir Isaac Newton refracted a beam of light, the colors separated and a full spectrum was produced—the same phenomenon we observe when sunlight bends through moisture particles and makes a rainbow.

When analyzing the elements of a scene we intend to paint, our minds focus on an object or area, and we immediately associate color with it. This color association can be easily exaggerated, allowing us to believe the color is brighter and more intense than it actually is. Then we move on to the next area and do the same, eventually producing a disjointed painting that lacks harmony. This exaggeration tendency affects the relative lightness and darkness of subjects, as well as the value range, which leads to overstated value separations.

Seeing Color Temperature

Before you figure out the colors, figure out the temperature of the light. Look to the light for a bias. Is it yellow, orange, rose or a violet-gray? By starting with the temperature of the light, you'll be well prepared for the individual colors of the objects.

Our minds tend to associate certain color families with specific objects, and this is another obstacle on our path. Strive to see color with sensitivity, to turn off your preconceived notions of what color an object should be. We've all seen paintings that are well-drawn and have proper value ratios, but that feel plastic and artificial, because the artist ignored the temperature of the light and the relationship of the colors to one another. The artist painted each individual object, focused on the details and

neglected to take note of the shared light and air surrounding each object.

Focus on the Light

Remember that what unifies a scene is the light. As the temperature of the light changes, so does the color of the objects. Many artists fail to observe the shift as the light changes, allowing the color they have assigned to an object to override what's right in front of them. These shifts are another reason not to work on location for more than two or three hours. Any longer than that and the color shifts are so severe that only the mature plein air painter can retain control of the painting.

Try this exercise: Place a piece of white paper outside and observe it throughout the

day. Note the subtle shift in both value and color as the day unfolds. Then learn to look for such shifts in the scenes you're painting.

Although a valuable tool, photography is never accurate in value ratios and color harmony. By working from life and being sensitive to the natural color harmony, you'll acquire good intuition and make better color/value choices when working from your photos back in the studio.

To have better control over value and color choices while painting, I lay my palette out the same way, whether in the studio or the field. Having this consistency of pastel placement makes it easier to ascertain subtle color relationship, value ratio and chroma intensity between individual pastel sticks.

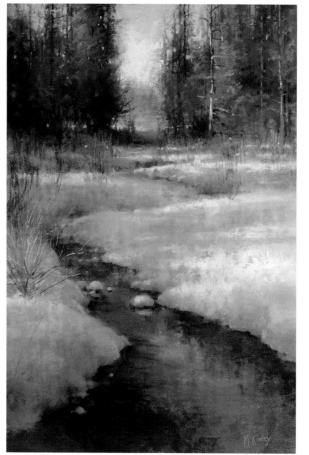

Sapphire Afternoon, 18" × 12" (46cm × 30cm)

LIGHT'S INFLUENCE
When determining the temperature of light, it is often hard to see beyond the associated local color—skies are blue, trees are green and rocks are brown. We have to look for the bias of the light source and make sure it affects every area of the scene. The evening light of *Sapphire Afternoon* provided a soft warm quality that saturated the otherwise cool nature of the local color. As areas became lighter, I added yellow and rose tones to facilitate that effect.

Light and **Value**

Light is the most important physical element in the painting; it's truly the means by which we perceive. Most beginners expend too much energy rendering the individual objects without addressing the one thing that separate elements have in common: the light. By knowing light's ways and moods, we're better able to transfer them to a believable painting.

Early in my career, when I was painting portraits, an instructor told me, "If you get the value ratios wrong, all the perfectly drawn proportions in the world won't make it look like that person." We must learn to see in relative terms. What appears to be light in one area may well be a shadow in another. In landscape painting, beginners can struggle with the value ratio in trees, for example. They see lighter areas on the form of the foliage and think highlight, but if they took that light area of foliage and placed it on the sky, it would be darker than any shadow on a cloud. To see these relationships, try to see what lies before you as massive areas of illumination and less as individual objects. By massing in areas that are of similar value, you'll be better able to know what constitutes a shadow and a highlight within that area.

Viewfinders and Value Maps

A number of viewfinders on the market can help the beginner or the value-challenged artist by blocking out most of the color and showing a monochromatic image. I recommend the Picture Perfect "3 in 1 Plus" Viewfinder, which has a red filter for gauging values, along with a gray scale.

A value-map thumbnail sketch can also help. To start a value map, block in the areas of illumination, giving yourself no more than four values to work with: dark, dark middle, middle light, and light.

Ignore black and white; retain them as accents. As the painting progresses, step back from time to time and review the big shapes of light, middle and shade. Look again at your value map sketch. Make sure that any given area on your painting hasn't seduced you into overly exaggerating its value range. If you can stay in touch with the scene as it's affected by the light, the overall believability of the painting will be strengthened.

Lean Toward the Color of the Light

Applying what you observe to your pastel work is a matter of choosing colors that lean toward the color of the light. Late in the day, for example, the color of the light may have an orange bias. This would make a warmer, slightly olive green a better choice for the tree foliage, and accordingly, warmer choices for the other elements within the painting. A method I often use to tie the color of the light into every area of the painting is to pre-select a range of values around the color I feel the light is emitting. If it's a soft amber, then I will select five or six pastels in values from dark to light to represent the light, adding a little of the appropriate value to each area of the painting. By staying true to the value of the individual areas, the form is retained and just the color is being shifted towards the temperature of the light.

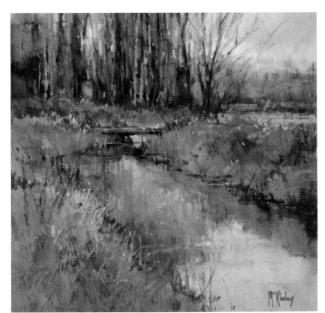

SETTING VALUE RELATIONSHIPS

In *Winter Canal*, it was helpful to look at the scene through a red viewfinder. The reflection and grassy bank may have been different in color but they were similar in value. By associating a general value to each large mass within the scene, lights and darks are easier to ascertain. Here, what is a light in the dark tree mass became a shadow in the bank.

Winter Canal, 12" × 12" (30cm × 30cm)

Determining **Value**

Relating value (the relative lightness and darkness of things) to color can be a tricky exercise. When color is intense (high in chroma), this becomes even more of a challenge. Since chroma is easily related to brightness, it's common to associate lightness to it as well, leading to value confusion. This is usually the culprit when we're having a hard time associating a proper value to a given pastel stick. Grayed tones become much easier to identify. The color is diminished, allowing for the value to be easily distinguished.

It's worth noting that in wet media, the base pigment often appears darker, by as much as two values, and richer in appearance. Think of this like a rock viewed in a stream bed. When wet, it is a jewel, filled with rich lush colors. Once dry it appears dull, lacking the luster that initially drew your attention. This explains why all those jewels I picked up as a child along the streams that ran through the woods of Oregon were nothing more than rocks when I pulled them out of my pockets hoping to impress my mother. To better understand the change in the appearance of pigments when they're wet or dry, compare Burnt Sienna straight from an oil paint tube to pure Burnt Sienna in pastel form (which has not been affected by the addition of white or black). Most manufacturers will indicate pure pigment on their labels or printed color charts. After witnessing the difference many pastel artists decide to work in a higher key, raising the value scale and avoiding overly dark pastel applications. Traditionally, black pigment was added to pure base colors to darken them and this produced dead, dark tones. Today many manufacturers are combining rich dark pigments in the making of their darker pastels, providing much richer darks.

Training the eye to see value and to not be overwhelmed with color takes time. When arranging pastels by value, it helps to make marks of the color on white, black and middle gray (something close to halfway between white and black), or on a value scale representing no more than nine values between white and black. Then close one eye and squint way down. If the mark nearly disappears, it is close in value. If it stands out as noticeably lighter or darker, you'll have a better idea of where it resides on the value scale.

| 0 | 1 | 2 | 3 | 4 | 5 | 6 | 7 | 8 | 9 | 10 |

ARRANGE PASTELS BY VALUE USING A VALUE SCALE
When you squint—the red is close to value 6, the blue is close to value 3 and the yellow is close to value 9.

Value **Benchmarks**

We have all heard the old painting adage, "Start with the darkest dark." In painting media where the individual pigments will mix together, like pastel and oil, it's easy to get muddy value/color relationships when this adage is not followed. Dark areas rarely have intense colors and when painted thinly, allow brighter, more intense lights to be placed on top without becoming chalky. The problem with this concept is that most painters lose sight of the larger value relationships within the compositional design of the painting. By focusing on individual dark accents instead of the larger value masses, the painting can become fragmented and contain overstated value ranges, creating an artificial appearance.

Generalizing a composition into three or four large shapes and associating an average value to those masses allows us to retain value integrity. All of us are capable of seeing too much and this can easily get in the way of representing the core relationships of the subject matter. We do it with details, color nuances, and light and dark values. Like the old saying goes, "We can't see the forest for the trees." When a general value is associated to these simple shapes, a benchmark is created that everything else must relate to. Darker and lighter accents will appear in relationship to that general value. This maintains the integrity of the scene as a whole. As an example, if a field in the foreground is averaged value 7, using a value scale with black represented as 0 and white as 10, the darker accents within the field would be value 6 and 5, and the lighter accents would be 8 and 9. The same painting may have a large mass of trees in the middle ground that average value 4, making value 3 and 2 its darker accents and value 5 and 6 its lighter accents. A light in the tree mass would instead be a shadow in the field mass. Without this observation, it is easy to associate extreme values to lights and darks, which creates an extended value range within a painting and makes it look artificial.

Doing sketches that represent the simple masses of the scene in advance of a painting and associating a general value to each mass will help to avoid overstated value relationships. Keep the sketch near your painting as a reminder of its value structure. Value masses can also be implemented as an underpainting technique upon which heavier applications of pastel will be placed as the painting progresses. Whichever method you use, understanding the simple shape structure of a painting and the general value of those shape masses will improve your painting's value structure and lead to a stronger finished work.

THE IMPORTANCE OF VALUE RELATIONSHIPS

Here, middle gray is placed on a darker and lighter mass. In one it becomes a light, in the other a dark. What is dark in one area can be light in another. It's all about relationships.

Color **Harmony**

Drawing creates accuracy of width and height; value produces the weight and form; color, however, speaks directly to our emotions. I often remind students that value does the work and color gets the glory. Since sunlight contains all colors, all colors must be represented to some extent in every portion of the painting in order for it to have color harmony. That requires the presence of the three primaries—yellow, red and blue—in greater or lesser proportions. These are the colors that can't be mixed by combining any other colors. If one is left out, the overall balance is affected. This is not to say that a pure color cannot be used to a large extent throughout the painting, but the others have to be represented in every part, even if minutely, or there will be no harmony.

Most successful paintings are dominated by one color. The other colors are affected by its dominance and work together in harmony. One way of applying this concept is to select a color family to be the major presence in the painting, placing it, to some degree, in every section. Applying the other color families in a lesser amount will make them subordinate. The addition of gray is another good means of injecting color harmony into a painting. Since gray is made up of all color, it will accent and harmonize with any other brighter color it is placed near.

Visualize Color Relationships

When looking at the scene, try scanning instead of staring without focusing on any given area. With practice, this visual exercise can greatly enhance the ability to see comparative relationships in the scene.

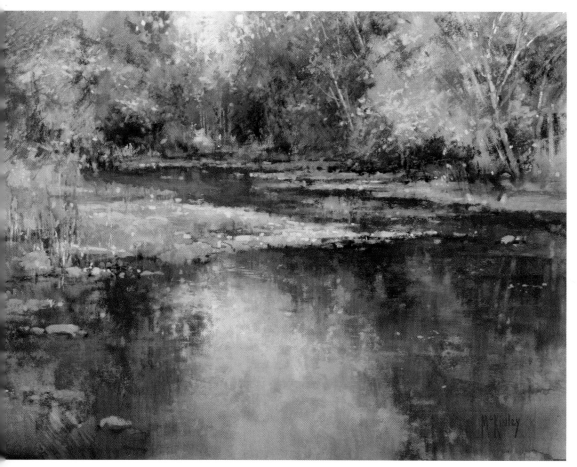

CREATE COLOR HARMONY AROUND THE DOMINANT COLOR
When using blue as the dominant color, orange is the complement (or opposite) color. Split apart it becomes yellow and red. As you can see, with any color choice as the dominant, all colors, to some extent, will eventually be represented.

Quiet Reflections
12" × 16" (30cm × 41cm)

Simultaneous **Contrast** Theory

The German artist and educator Josef Albers said, "Simultaneous contrast is not just a curious optical phenomenon; it is the very heart of painting." Simply stated, simultaneous contrast implies that everything is affected by the opposite of what it's placed next to. Something will look lighter when placed next to something dark, and warmer when placed next to something cool, and vice versa. A weaker grayed color will also appear brighter or more dull, and warmer or cooler, depending on its adjacent color relationships. It's the color relationships that create color excitement. Think, for example, of an intensely blue sky that makes a gray mountain appear warmer and almost peach in hue.

I'm fairly tall (6' 3" [191cm]) and in most situations I appear tall, but if I'm on a bus with professional basketball players, I appear short. I didn't change, but my context did. When we paint, areas of shadow and light and opposing colors, get us into trouble. We associate black and white to the areas of light and dark, and exaggerated color saturations to individual colors, forgetting that they share a visual relationship with surrounding values and colors.

By looking at the color example and value scale illustrated on this page you'll see that what appears to be cool in one setting can become warm in another, and what appears to be a highlight in one area becomes a shadow in another. They didn't change, but their relationships did. This is why the choices we make when painting have ramifications. It's all about relationships.

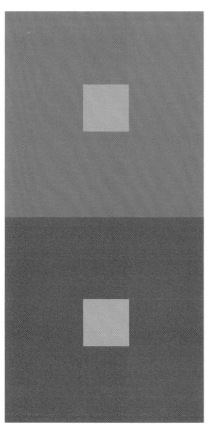

SIMULTANEOUS CONTRAST: EXAMPLE 1

This illustration of simultaneous contrast shows how the same gray value appears differently depending on its adjacent color. In this case, it appears cooler on bright orange, but warmer on bright blue.

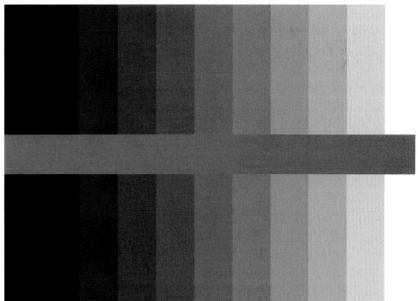

SIMULTANEOUS CONTRAST: EXAMPLE 2

In this value scale, representing black to white with a middle value running through the middle, notice how each side of the individual values change; the middle value strip looks darker or lighter depending on its relationship to the other values.

Aerial **Perspective**

When artists paint, they create the appearance of something real from something that is not, producing an illusion. Pigment deposited on a surface magically becomes something recognizable. And, by properly rendering a drawing, value relationships and color associations, they create something that looks real.

One of the strongest tools an artist has for creating this illusion is the phenomenon known as aerial perspective, sometimes called atmospheric perspective. Leonardo da Vinci, through his observations, described it as "the perspective of disappearance." A better understanding of the science behind aerial perspective makes it easier to employ it as a tool for portraying depth in landscape work.

Why the Sky is Blue

Aerial perspective describes the way an object's appearance is altered by the atmosphere between the viewer and the object he or she is viewing. Atmosphere—which comes from the Greek word *atmos*, meaning vapor, plus *sphaira*, meaning sphere—refers to the layer of gases, water vapor and smoke (haze) that may surround a material body of sufficient mass. A key condition affecting atmosphere is the scattering of daylight, which becomes skylight. The short or blue wavelengths of light are the most easily scattered by the particles in the atmosphere, which is why the sky is blue. This scattering adds the skylight to the reflected light of the object being viewed, making it appear bluer (cooler in color temperature), weaker in value contrast and fuzzier.

Since a painter is looking across the surface of the landscape, this effect becomes compounded as things recede into the distance, and is altered by elevation and general climatic conditions. Da Vinci went so far as to make a mathematical equation to apply distant perspective: Paint the nearest area its true color. Paint the one behind proportionately bluer, and the one behind that bluer still. "Thus, if one is to be five times as distant," da Vinci said, "make it five times bluer."

The Third Dimension

In *Carlson's Guide to Landscape Painting*, artist John F. Carlson refers to atmospheric perspective as the third dimension—the prime means of creating a sense of space and air in an otherwise two-dimensional surface. Stated simply, the effect of aerial or atmospheric perspective is that objects get cooler in temperature, lighter in value, grayer in brightness and softer in edge as they recede. Thinking in terms of basic color families, yellow falls away quickest, becoming a weak tan and eventually a silver-gray. Red is next to fade, transforming into violet and eventually gray-blue-violet. Blue carries the farthest, getting slightly grayer, as well as lighter, as it recedes. Darks become cooler and lighter, with light white objects becoming cooler and eventually slightly darker as the scattered distant light affects them.

Applying Aerial Perspective

When applying the lessons of aerial perspective to my work, I use a simple order of

ATMOSPHERIC MANIPULATION

In my painting, *Long Shadows*, I purposely made the large cast shadow in the foreground warmer and darker near the bottom, though in reality it looked pretty much the same. The effect is that you feel a heightened sense of distance as you journey through the painting back to the old stone structure.

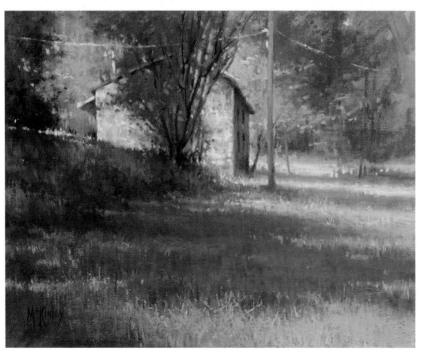

Long Shadows, 11" × 14" (28cm × 36cm)

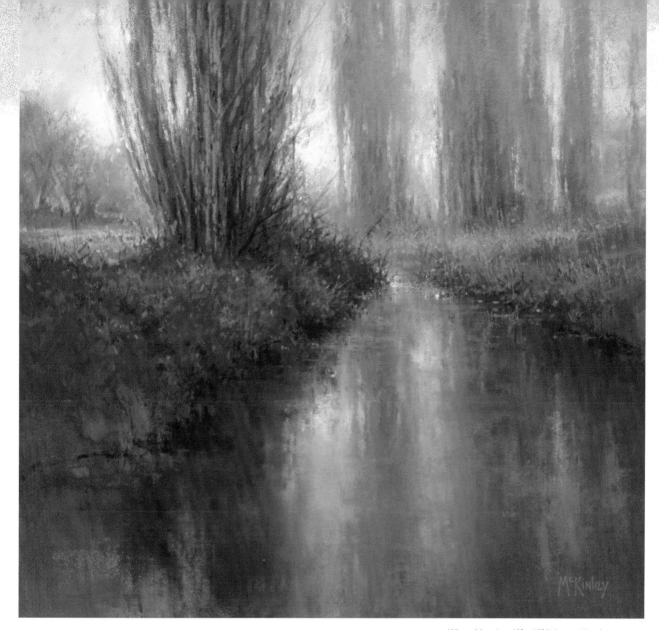

Winter Morning, 18" × 18" (46cm × 46cm)

influence: cooler, lighter and finally softer. First, I attempt to make things warmer in the foreground and progress to cooler in the background, even if this isn't easily visible within the scene. My next step is a darkening of the foreground and general lightening of the background. I avoid softening objects as they recede into the background if I can, for reasons connected to the area of interest and focal points.

Using this system may, admittedly, lead to a degree of confusion in certain situations. What if there is something warm or dark in the distance, and a cool light mass in the foreground? The thing to remember here is that everything is relative within the framework of the painting; it all shares a relationship. It's perfectly acceptable to have a dark area or warm object in the far background and a cool or light object in the foreground, as long as they relate properly to the other distances within the painting. Make a game out of this as you apply your pastels to the three zones of the painting: foreground, middle ground and background. Ask yourself, "Could I make this element even warmer and darker if it was in the front? Could I make it cooler and lighter if it was in the back?" If the answer is "yes," then you have chosen your pastel temperature and value wisely.

SMOKE AND FUMES

In the painting *Winter Morning*, all the tools of atmospheric perspective were employed. Colors become cooler in temperature and grayer in intensity as they recede. Values become generally lighter and edges soften. It is the Italian word *sfumato* (as if through smoke and fumes) being put into action.

The Color **Wheel**

Whenever color is concerned, it's best to begin with the color wheel. By studying the relationships of individual colors and how they interact with each other, we develop a better understanding of why certain colors work when placed together. This is a powerful tool in choosing what to place in a painting. Nature works. It shares an atmospheric relationship and a light source that creates the natural appearance we accept. Our paintings, on the other hand, are created "artificially" with pigments on a flat surface. We have to create the illusion of reality and harmony.

Pastel by its nature facilitates a spontaneous application of color. Being a dry medium, mixing is achieved by layering one color over another. This dry mixing is incapable of duplicating the subtlety and variety of wet paint. For this reason an assortment of individual colors, chromas and values is needed. Otherwise we're limited in our ability to accomplish the full spectrum of other art media.

Types of Color Wheels

Even though pastel artists don't have to mix individual pigments to achieve a variety of hue, value and chroma, an understanding of the color wheel can be used to strengthen our paintings. Color wheels show the relationship of individual colors derived from light. Today there are two common wheels in use: the triadic, which consists of three primary colors, and the Munsell, which consists of five.

Triadic Color Wheel. The most prevalent color wheel is the simple triadic wheel with its three primary colors. It has worked well for centuries and is a good place to begin. Its primaries of yellow, blue and red are easily understood and simple to apply. There are many commercially available Triadic wheels on the market with most showing complementary, analogous and split complementary (or discordant) color relationships (see sidebar on opposite page).

Munsell Color Wheel. The other color wheel you'll run across is the Munsell. Around the turn of the last century, a problem occurred when printers attempted to reproduce a full spectrum of color in printing. They simply couldn't do it with the three basics from the triadic wheel. This led professor Albert H. Munsell, through study of "human visual responses to color," to create what's referred to as "a color space," consisting of three-color dimensions: hue, value (lightness) and chroma (color brightness or purity). He concluded that to represent color accurately, there had to be five primary colors: yellow, green, blue, purple and red. This led to the adoption of cyan, magenta, yellow and black (CMYK color space) for printing. Cyan is a blue-green, magenta is a red-purple, and with yellow, they represent the five primaries he advocated. This is still the system used in all press-run printing today.

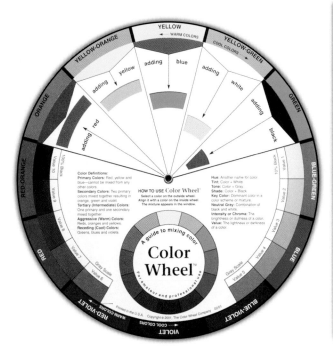

TRIADIC COLOR WHEEL

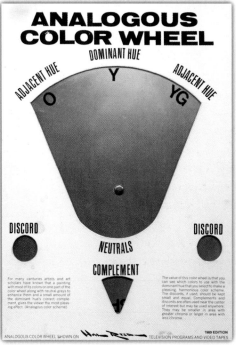

MUNSELL COLOR WHEEL

Building Color **Confidence**

We all love color. It's one of the most seductive components of painting. When used with understanding and sensitivity, it can lead to successful results. When left unchecked, it can become disturbing and appear artificial.

When we look at our subject matter, things share a relationship. Objects relate to each other, sharing the same light source. This produces a natural harmony and a sense of rightness. Since painting is an illusion, a trick if you will, we have to capture that natural sense to the best of our ability, and we're hindered by visual prejudice. We associate colors to objects and let that symbolic association guide us when making color choices. Skies are blue, trees green, and people pink. A color scheme, arranged from a color wheel, can help in making harmonious color choices.

Many commercially available color wheels have common color arrangements indicated such as analogous, complementary, triadic and split complement (discordant). By choosing a dominant color for the painting, and selecting it on the wheel, we can quickly see these relationships and make our pastel selections accordingly. However, the color wheel is not the absolute truth, telling us what colors we must choose, but a tool. By employing these color schemes, color confidence will be built—leading to a heightened sensitivity for the natural color harmony all around us. Many of us remember the first time we painted a hillside with the guidance and influence of an instructor. Our eyes were opened to the variety of greens before us. After that experience, it became easier to witness these subtle variations.

Types of Color Schemes

A color scheme is the group of colors used in a piece of art. By employing a color scheme derived from a color wheel, you'll be able to strengthen your natural intuition and, after time, be able to simply experience the scene and make wise choices. This will lead to a successful harmonious outcome.

Monochromatic color schemes *are one hue (color) altered in tint (addition of white), shade (addition of black) and tone (addition of gray). The monochromatic scheme relies on lightness, darkness and saturation to produce a varied appearance. Example: Red altered with the addition of white, black and gray.*

Analogous color schemes *rely on hues that are adjacent to each other on the color wheel. One color dominates the scene with its brother and sister colors for accent. Tints, shades and tones are employed as well, making it a variation of the monochromatic color scheme. Example: Dominate color red and adjacent colors red/orange, and red/violet altered with white, black, and gray.*

Complementary color schemes *consist of two opposing colors on a color wheel. This scheme creates contrast. It is imperative that one color dominates with the opposite, complementary color, subordinate. Tints, shades and tones of the opposites are used. Warm and cool opposites create the best outcome. Example: Red and green.*

Split complementary *is a variation of the complementary color scheme where the opposite color is split into its adjacent colors. It produces the effect of the complementary scheme without the tension. Example: Red and the adjacent colors of green—blue-green and yellow-green.*

Triadic color schemes *use three colors that are equally distanced from each other around the color wheel. This scheme creates a sense of balance and harmony. It is important that one color dominate with the others acting as accents. Tints, shades and tones are employed to alter the appearance of the hues. If the scheme looks intense, try altering some of the colors with additional gray to create more harmony. Example: Red, blue and yellow, or orange, violet and green. Since the latter colors are mixed from the primaries, a natural harmony already exists.*

Gray and **Neutrals**

One disadvantage that separates pastel from its wet cousins is the inability to mix individual pigments easily to produce natural color harmony. For example, many oil painters begin by learning to work with just three tube colors and white on their palettes. Every color is mixed from these.

In pastel, gray—or neutrals—can be thought of as the perfect harmonizer. By utilizing opposing (complementary) colors, which always have the other two primaries in them, a weaker color is produced. A balanced combination of these primaries produces a gray or neutral color. Since neutrals have a degree of the other color families represented in them, a natural harmony with brighter colors is produced when they're placed in close proximity. If a painting appears too harsh in raw color, select one color family to be intense and then a full range of grayed variations.

To better internalize the concept, try placing grays, or neutral tones, on a variety of colored surfaces. What appears warm on one will appear cool on another (see the illustration on page 47 in which I placed gray squares on a bright orange versus a bright blue). It's not the pastel stick that changed, but rather the color with which it's interacting. Turn to these "neutrals" as your first choice when building a painting, progressing to the brighter, high key hues for the final touches. The more neutrals employed, the more color harmony you'll see, because each neutral already has a bit of the other color families built in.

If you prefer to use higher chroma colors (brighter saturated hues) and wish to avoid grays, you can achieve similar results by layering opposing colors at the proper value. For a green field, a rose red could be applied as a thin pastel layer first, with green pastel laid on top to interact with the rose and complete the spectrum.

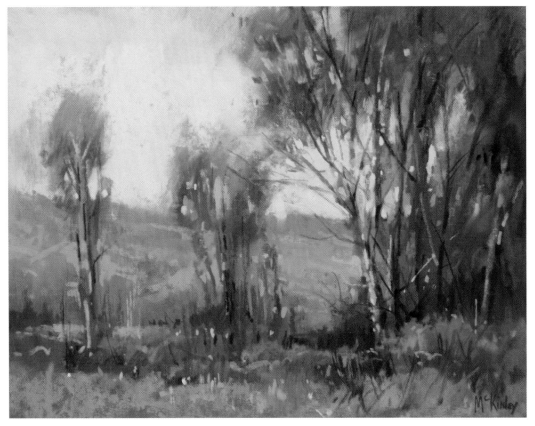

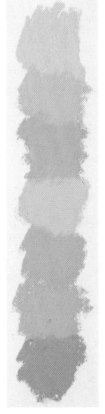

Eucalyptus of Santa Barbara, 9" × 12" (23cm × 30cm)

STRIVE FOR THE FULL SPECTRUM

Here I used a full spectrum of grayed colors in the field sketch, then added accents with a few brighter tones.

Creating **Luminosity**

Creating a luminous effect with pastels can be achieved through the fracturing of local color while retaining value consistency.

When light is strong or highly reflected off a variety of surfaces, it can appear to glow. The easiest way to duplicate this in a pastel painting is to use a variety of colors in any given area without changing the value. Value represents the weight or form of the object. Tampering with it will make the structure fall apart, producing an amateurish look. Sir Isaac Newton proved that white light is made up of all color. When he bent the light, it separated into individual colors, producing a rainbow effect. Light is also energy. It's a pulsation—striking and reflecting off surfaces throughout our field of vision.

Being unable to physically capture this energy force and apply it to our pastel surfaces, we rely on a few techniques that help in creating a luminous appearance.

Fragmenting

One way to heighten the appearance of light in a painting is to employ fractured color. Besides adding to the harmony of the painting, it also adds luminosity. This is especially true in areas that represent an abundance of light, such as a sky or a reflection on water. Placing a bit of the full color spectrum at the proper value causes the viewer to sense the vibration of light.

When a specific color is required, such as a blue sky, work analogous: blue, blue-violet and blue-green. The viewer will see blue—the dominant color saturating the sky—but a bit of red and yellow have been thrown into the mix, completing the spectrum. When attempting to represent pure light, those gleaming little sparkles equally represent all color at the proper value. A fractured color application will always produce more luminosity than a single color choice applied to an area.

Halcyon Effect

Another means of heightening the appearance of a glow or luminosity is to create a halcyon effect. Instead of creating a hard edge all around an object, soften or blur the edge near a highlight, as the light would reflect off the surface. This blur will give the appearance of light bouncing off the object, creating a strong glowing effect. This works very well on objects or surfaces that have a strong curve and the light is striking them from an angle. I like to think of the light as a forcefully thrown ball. When it hits the surface, where would it bounce? Place a little smudge there.

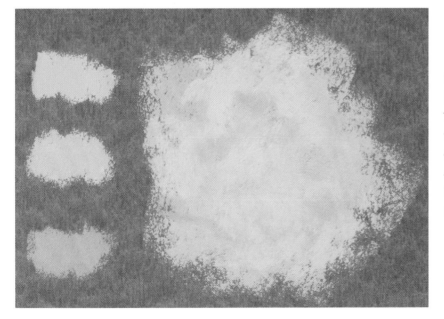

FRACTURED COLOR HEIGHTENS ILLUMINATION

This example of an analogous color fracture works with blue, blue-violet and blue-green—a combination that contributes to a luminous effect. (See how fractured color increased the luminosity of the finished painting on page 40.)

The Limits of **Green**

Green is one of the tougher colors to work with in pastel; with green, a little goes a long way. Pastel artists have an especially difficult time using green because so little blending is utilized to produce individual hues. We rely on hundreds of sticks while a wet painter might have as few as four tubes of paint. Most green pigments, in their raw form, are artificial to foliage, either too blue (cool) or oversaturated (bright) to work well unless combined with another pigment. Even the strongest blue-green in nature is rarely as intense as pure Viridian or Phthalo Green pigment. Layering and intertwining other colors over these harsh tones is one way to produce more natural-appearing greens, not to mention an excellent method of uniting and harmonizing a painting.

Seek Out "Mixed Pigments"

Most manufacturers that offer a limited number of colors in their pastel lines suffer from an abundance of these harsh tones. Other manufacturers with extensive color offerings usually mix pigments together to expand their color range. By mixing pigments together, they duplicate the subtle temperature shifts that wet painters are capable of producing by mixing on their palettes. This helps pastelists produce more natural-appearing green tones and has made painting the landscape with pastel much easier. If your pastel palette is small, it will serve you well to add some of these mixed green sticks, thus alleviating one of the issues with green.

FILL YOUR PALETTE WITH MIXED GREENS
When considering green in your palette, acquire blended green pastel sticks, the warmer the better. Don't select them based on their pigment name. Look at them and ask yourself: Does this stick represent something I would mix if I were painting with wet paint?

Harmonizing Green Pigments

Science has shown us that light is made up of all color. It is an additive synthesis. It gets lighter and brighter as it's mixed. Pigment, on the other hand, is a subtractive synthesis. It gets darker and weaker when mixed. The three primaries of pigment color, from which all the other colors are derived, are yellow, red and blue. They share no relationship until mixed. When mixed, they create what are referred to as the secondary colors: orange, violet and green. These secondary colors share a common thread. Any combination of them completes a color wheel, creating natural harmony.

Other colors within your scene have an effect on your green pastel choices. Understanding the color wheel and color theories such as simultaneous contrast theory is empowering, but it still comes down to what is placed on your painting. Make a mark and then another. As the surface becomes covered, it will become apparent whether the green choices are working. If not, increase the presence of violet and orange, completing the triadic scheme of green.

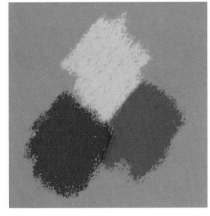

PRIMARY COLORS

SECONDARY COLORS

CONSIDER TRIAD COLOR SCHEMES
Add orange (the secret) and violet (the friend) to large green masses even if it's in the underpainting. Adding a touch of red to the mixture of yellow and blue (green) introduces orange, completing the primary color group, making the harsh mixed-green appear warmer. Placing a little violet of the same value next to a mass of green counteracts the harshness of the green, making it appear a little more yellow, again pulling it toward a warmer appearance due to simultaneous contrast.

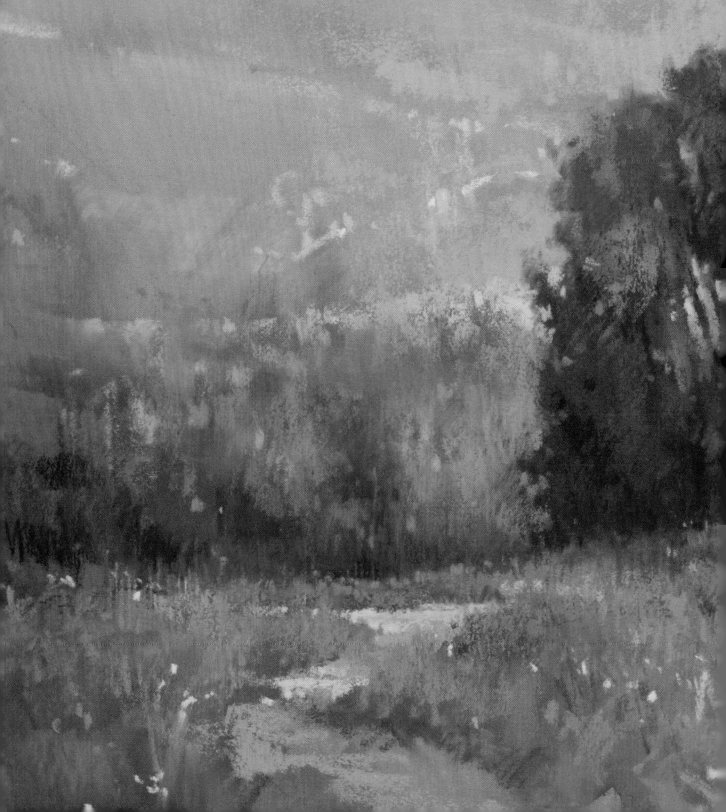

The Underpainting

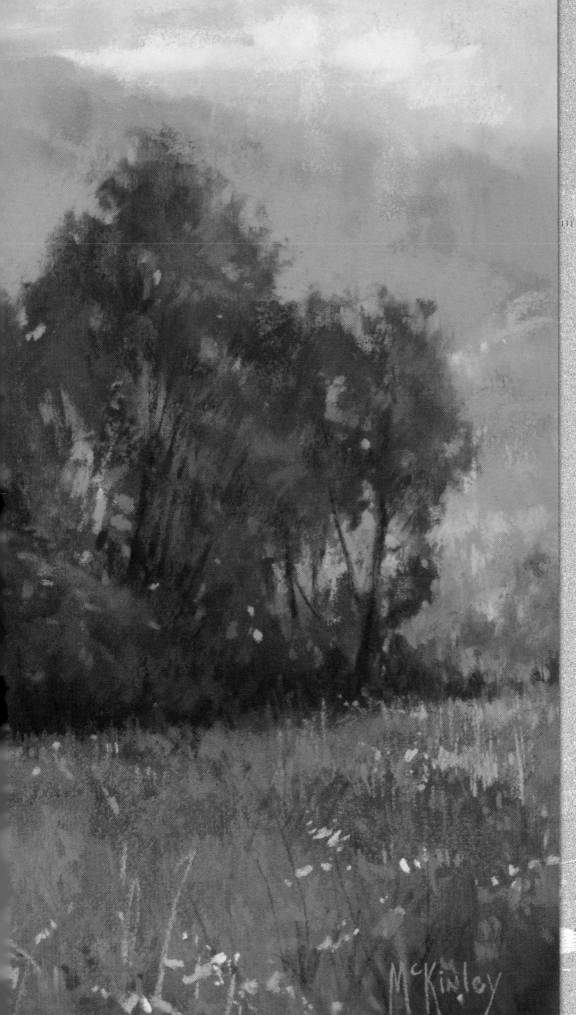

4

Basics of the **Underpainting**

An underpainting is one of many techniques pastelists use to expand the creative potential in their work. An underpainting is a preliminary painting—a layer of color or tone applied in advance of the painting itself. It usually represents composition shapes, light and dark values, and color choices. Think of it as the initial layer of paint or pigment applied to a surface that serves as a base.

Historically, classical artists often did monochromatic underpaintings, referred to as *grisaille* (gray) or *verdaccio* (gray/green). These gray underpaintings represented the value form of the painting to which subsequent layers of color would be applied. Even though gray underpaintings were a popular practice and continue to be used by many successful artists today, not all were monochromatic. Artists such as Giotto di Bondone (Italian, ca. 1267–1337), Jan van Eyck (Flemish, ca. 1395–1441) and Titian (Italian, ca. 1488–1576) often utilized multi-colored underpaintings. The father of modern pastel painting, Edgar Degas (French, ca. 1834–1917), was aware of these techniques and also experimented with a variety of undertones and underpainting procedures throughout his career.

A Choice of Media

Depending on the surface being used, an underpainting can be created with pastel or a number of other media. When pastel is used, it can be brushed with water or mineral spirits to create a painterly effect. A light application of pastel can also be rubbed or smeared with a strong paper towel, or a variety of foam products such as packing peanuts or even plumbing pipe insulation cut into small sections.

You can also create underpaintings with water-based media such as watercolor, gouache or pure liquid pigments. Even highly thinned oil paint can be used on some surfaces, producing interesting effects.

Since traditional forms of underpainting relied on a separate dry layer, additional layers of value and color could be applied without physically blending and creating mud (every painter's nightmare). To avoid this mingling of value and color with pastel: Work thinly, employ a layer of workable fixative, or underpaint with a medium that dries. As long as you take care that what you're using is archival, you should feel free to experiment to your heart's content, until you find the effects you like best.

A Note on Notan

One of the more traditional ways to employ an underpainting is to create a *notan*. In Japanese, notan means dark/light and refers to the arrangement of dark and light spaces within a composition to create harmony. A notan represents the quantity of reflected light, or the massing of varied value tones, that creates a design. Whereas we observe light and shadow, and use it to model individual form, with notan, we're generalizing abstract areas within a composition into

A NOTAN UNDERPAINTING
For *Afternoon Rains*, I began with a notan value underpainting. I worked on UART sanded paper and used violet-gray hard pastel, which I set into the surface by wetting with water.

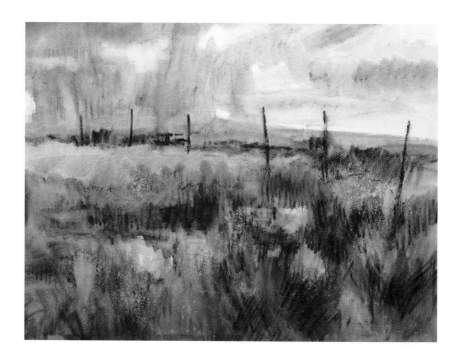

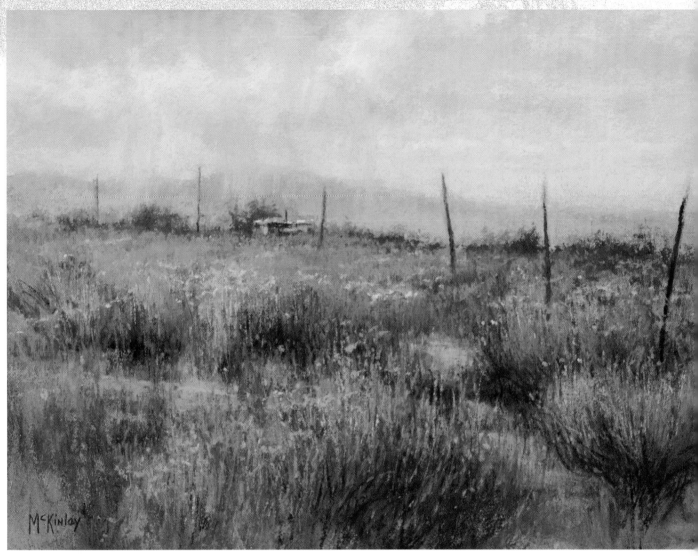

Afternoon Rains, 12" × 16" (30cm × 41cm)

value masses to provide a better understanding of the overall value design.

To create a notan, work with as few values as possible, creating an abstract pattern of value. Allow this notan underpainting to set the value mass arrangements and then model values throughout the painting to create the individual forms.

For landscapes, artists commonly use a cool/dark tone, similar to a dull Payne's Gray, or a warm/dark tone, similar to Burnt Sienna, to mass in the darker values. If the surface allows for wet media, you can use water or mineral spirits to create a thin stain that will easily accept subsequent layers of pastel. Notan underpaintings help to keep the value cohesion intact as the painting develops.

A Solid Foundation

Your underpainting can reflect the techniques of the past or employ new, more modern ways of expression. It can represent the large shapes that make up the composition, emphasizing the average value mass of the area it represents, or it can be loose and expressive, acting as a catalyst for creative responses.

No matter how you decide to approach the process, remember that the underpainting serves as the setup before the final application of pastel. It's not meant to be the finished painting in its own right but rather to act as the foundation. When it shows through and plays a major part in the final appearance of the painting, think of it as a reward—not the purpose of the underpainting but a bonus. Keep an open mind. When done properly, the underpainting enhances the overpainting.

Aerial **Perspective** and the Underpainting

Applying an underpainting can be useful for introducing aerial perspective into a pastel painting. By dividing the surface into three zones and gradually transitioning to a cooler, lighter appearance at the top, most distant area, an artist can set the foundation for the perception of depth (for an example of this, see *Canyon Rains* on page 64).

The jumps in color or value choices shouldn't be too distinct, as this can be jolting, producing a disconnected color harmony within the painting. Instead, we should work incrementally, allowing for subtle shifts. A good choice is to start with the temperature of the light and work with its warm and cool side. In a cooler painting, for example, a red-violet for the foreground, violet-gray for the middle ground and blue-violet gray in the background works well. For a warmer scene, a brown-orange in the foreground, rose-red gray in the middle ground and violet-gray in the background sets a nice stage. Responding to this underpainting leads to a finished painting that has a better feeling of distance.

Another technique that proves helpful is to select three values of a color to be feathered, or scumbled, into the painting to represent the skylight—often three values of a blue or blue-gray hue. Placing the lightest value in the background and the darkest in the foreground will, in varying degrees, achieve a sense of depth.

Also, the farther an artist is able to look into a scene, the more it's affected by the atmosphere and the scattering of daylight, leading to a heavier application of cooler/lighter pastel in the background than the foreground. This shouldn't be oversimplified, becoming a predictable formula. Instead, keep the notion in mind as a potential help for adding to the overall harmony and depth of an otherwise successful painting.

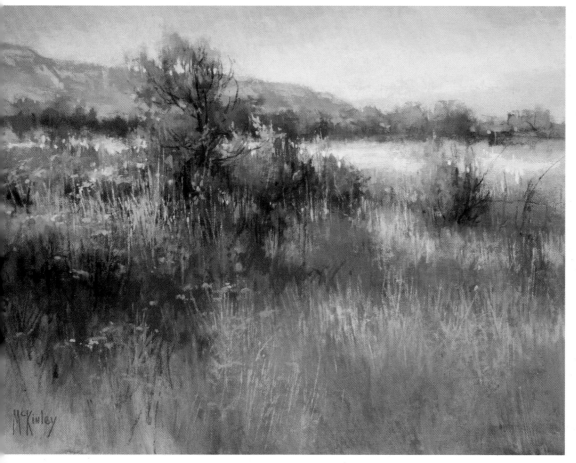

YELLOW—THE FIRST TO GO

I painted *Evening at the Malheur* on location in an area that provided perfect aerial perspective vantage points. The yellow fields quickly transformed into dull, silvery tans; the foreground colors were rich and saturated. Even the sky produced a dull, warm scattered light effect near the horizon.

Evening at the Malheur, 12" × 16" (30cm × 41cm)

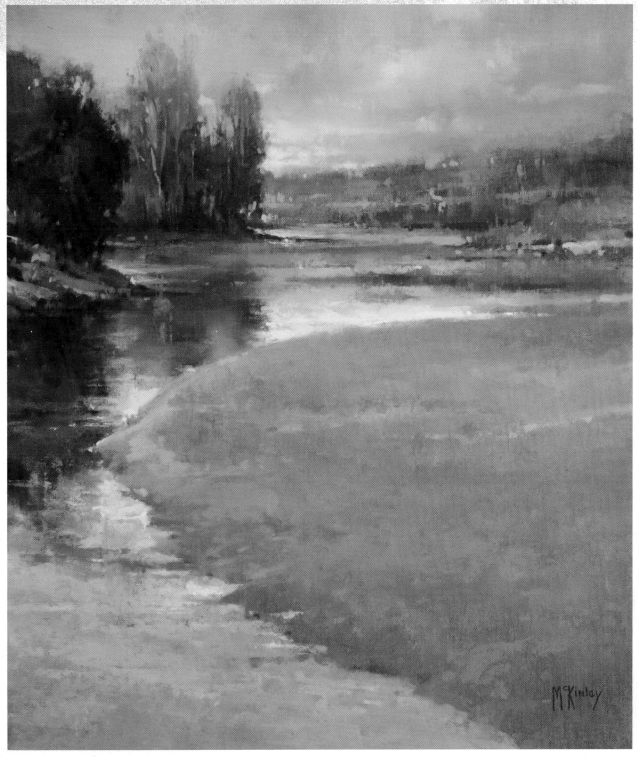

A Distant Glow, 14" × 12" (36cm × 30cm)

ADD BLUE-GRAY VALUES TO ENHANCE COLOR HARMONY

The atmospheric condition of this Pacific coastal scene lent itself to a sensitive study of subtle temperature and value manipulations. Selecting a few values of blue-gray and adding them to the foreground, middle ground and background achieved overall color harmony. Subtle additions to the background heightened the effect of aerial perspective without overpowering the scene.

Oil-Based Underpainting

Oil-based paints need special consideration when used for the underpainting, because the oils in the paints can be corrosive on some surfaces. Plain fiber papers won't work. If you want to use an off-the-shelf surface, find one that has been well-sealed: Wallis paper, Ampersand Pastelbord and Art Spectrum, to name a few. Homemade grit surfaces are also suitable. For an oil-based underpainting, solvent is the vehicle—and you will need a good one for this task. Gamblin makes one called Gamsol; Martin F. Weber Co. makes another called Turpenoid.

When staining your surface with an oil-based underpainting, the paint must be thinned to the consistency of tea. You are not doing a traditional oil painting, it is a stain. Make sure you use artist-grade paints, which will give you the best tinting strength. You'll therefore need less pigment to cover the surface. Depending on the surface you're working with, a wonderful alchemy can occur as you mix varying colors. And because solvent is much thinner than water, the runs and drips take on a look that I call "spider webbing."

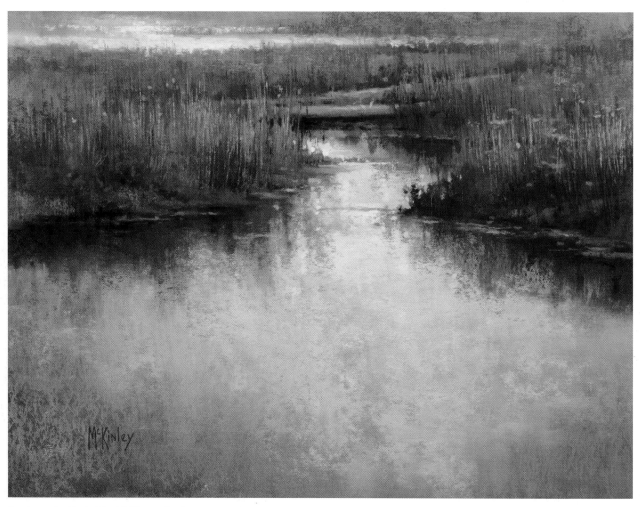

Evening on the Marsh, 12" × 16" (30cm × 41cm)

AN UNDERPAINTING IN OIL

Evening on the Marsh is a pastel over oil on Wallis gray Belgian Mist paper, mounted on a board. I knew I wanted to paint the lighter and brighter aspects of this scene, so I began with a neutral gray surface. The soft oil wash underpainting produced a lot of tiny runs because of the solvent, which created texture without being overwhelming.

Water-Based Underpainting

If you choose a water-based paint for your underpainting, be aware that most papers will swell and wrinkle, often drying to an uneven surface. To combat this tendency, stretch the paper in advance or have it dry-mounted, using an archival process. The most widely recognized form of archival mounting requires a dry heat press. A non-acidic tissue is placed between the paper and the support (in my case, museum board), then the layers are heated in a press until the tissue softens and adheres the paper to the support. This process is the same as the one used in fine art black-and-white photography and is reversible if you reheat the layers. It's well worth the added expense.

Acrylic

This is a good choice for tinting acrylic-based grounds. It dries to a permanent surface and has good saturation. The concern when using acrylic paint is its tendency to fill the tooth, leaving a slick, unreceptive ground for applying the pastel. However, if you use considerable water, as is customary with a traditional watercolor technique, acrylic can be quite exciting, because you can attain high chroma, and the acrylic ground will form a permanent film once it has dried.

Gouache

Gouache lets you use traditional water-color technique, and its higher chroma (due to its opaque nature) makes it a favorite with many prominent pastel artists.

Watercolor

Traditional transparent watercolors are a popular means of getting a fast, loose underpainting. Easily transportable, watercolors are the perfect companion when I'm working en plein air. Water is always available. Most artists use simple, traditional watercolors, whereas others employ the liquid water-based pigments available from Golden, Createx Colors and others.

Watch Richard demonstrate his underpainting techniques online at **http://mckinleyvideo2.artistsnetwork.com.**

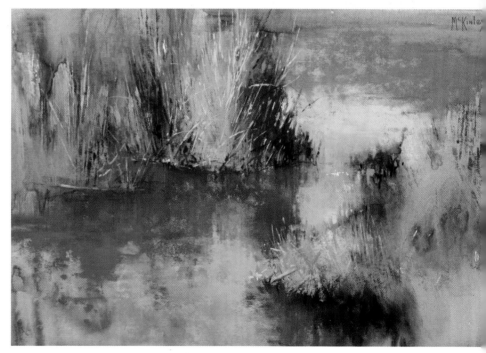

Morning Reflections, 12" × 18" (30cm × 46cm)

AN UNDERPAINTING IN WATERCOLOR

For a subject with a lot of texture, I like to do a watercolor underpainting, concentrating on large shapes, to contrast with the pastel and bring out its texture. It may sound paradoxical, but a soft, blurry underpainting allows me to create sharper edges, paint around something to explain it and orchestrate the application of the pastel to direct the viewer's eye.

Underpainting in **Pastel**

Pastel itself is quite capable of producing a variety of beautiful effects. It sets the foundation for subsequent applications of pastel and allows us to quickly get to the important marks of pastel while retaining a painterly appearance. When deciding what to put down, some pastelists make value the governing influence, while others choose color as the impetus to respond.

Dry Technique

Gently rub the pastel stick across the surface then spread the deposited pigment with a soft rag, strong paper towel, chamois rag or foam pieces (like pipe insulation cut into smaller pieces). Avoid overusing your hands for health reasons, and be careful of generating pastel dust during this process; do not inhale any airborne pigment.

When applying a dry application of pastel for the underpainting, the same value and color choices govern this technique as the wet methods. Ask yourself, "What do you want underneath as a setup for the pastel marks?" It is best to start with harder pastels so as not to fill the tooth of the surface; it takes very little pastel to create a foundation. Avoid overly dull pastels, as the smearing will naturally weaken the color. Be messy. Let the smears mingle across forms. It is much easier to define an edge as the painting evolves.

Mixed-Media Technique

Ever the inventive group, pastelists have experimented with a wide variety of methods and products for underpaintings, opening the medium to a variety of mixed-media techniques. If a painterly look is desired, pastel can be wetted with water, paint thinner, odorless mineral spirits, acetone or gum turpentine to create a fluid wash for spreading around pastel. Making pastel wet produces interesting effects as it drips and runs around the surface. The pigment pools and happy accidents occur. Remember that when pigment is wetted, it will appear brighter and darker. Once it dries, it will return to its original state. As exciting as these happenings can be, there are surface issues to consider. Water on a highly rag surface or lightweight paper can produce wrinkles. If you plan to use water, it is best to have the paper mounted in advance of painting. Alcohol-based products on an acrylic-primed surface tend to soften and smear the ground. Paint thinner and gum turpentine can have adverse effects on the appearance of certain pigments. Test for these in advance of painting by experimenting on a scrap of your preferred surface and mixing the solvents with the pastels you will be using. As long as the surface can tolerate the product being utilized and good archival techniques are employed, there is nothing to fear. Experiment, have fun and enjoy the creative possibilities.

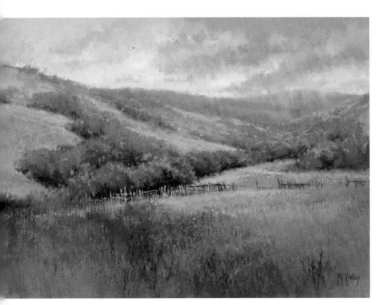

Canyon Rains, 12" × 18" (30cm × 46cm)

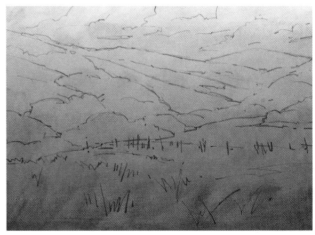

UNDERPAINTING IN PASTEL
Before I executed the drawing for *Canyon Rains*, I smeared pastel into the paper using a heavy-duty paper towel to create a soft underpainting that represented the underlying temperature.

Stories of Taos, 18" × 14" (46cm × 36cm)

AN UNDERPAINTING IN OIL AND PASTEL FOR A PORTRAIT

Stories of Taos combines pastel and oil washes on Wallis white museum paper mounted to a board. Using an underpainting for a portrait is as exciting as it is for landscapes. By letting the oil washes run and mingle together, I lost some of the over-controlling aesthetic so dangerous in portraiture. I used bits and pieces of pastel to define the structure of the face. When those pieces of pastel mingled with the underpainting, the result was both depth and color harmony.

Underpainting Exercises

Deciding what value, color and shape to place under the pastel painting can be a challenge. Some artists have spent many years experimenting and have developed a strong intuitive approach. To expedite the learning process, try this series of underpainting exercises. Start by selecting a completed painting, which you will copy for each exercise. Make sure the painting has strong contrast of shape, value and color. It's imperative that you select just one of your paintings to copy, as the point of the exercise is not to confront new subject matter but to interact with a variety of underpainting setups.

Choose nine pastel surfaces for the studies and work on that same surface for each study. If you wish to try out other surfaces, complete the entire series of exercises for each new surface. Keep the surfaces small enough to allow you to work quickly, but not so small that you don't have enough room to respond well with pastel—something about 9" × 12" (23cm × 30cm) to 12" × 16" (30cm × 41cm) is ideal.

1 Create a painting on a white surface.
2 Work on a black surface (a lighter surface can be stained with diluted India ink).
3 Work on a mid-value warm tone (similar to Burnt Sienna).
4 Work on a mid-value cool tone (similar to Payne's Gray).
5 Try a notan underpainting representing no more than three value masses (a cooler tone similar to Payne's Gray works well).
6 Do an underpainting using both warm and cool tones (Burnt Sienna and Ultramarine Blue work well). These can be intermixed to create a variety of tones and should employ a varied value range.
7 Do an underpainting using the local color associated with the subject matter. Use as many colors, mixtures and values as desired.
8 Do an underpainting using colors that are complementary to the subject matter, selecting the colors on a color wheel opposite to those representing local color.
9 Do an intuitive underpainting, selecting whatever color, value or mixture you wish. Let go and have fun.

After completing these exercises, you'll have internalized a lot of information about what it takes to react to a specific undertone. Don't make the exercises too precious. Remember, they're tools to facilitate underpainting intuition.

ENHANCE THE UNDERPAINTING WITH SPLATTERS OF WATER

I usually don't paint this large on location, but I had a strong concept for a painting that needed to be larger. After a simple line drawing, I started with runny watercolor washes that were soft and massive. As this dried, I added splatters and brushstrokes of plain water, a process I can't control and is therefore always exciting.

Frenchglen Sentinels, 16" × 20" (46cm × 51cm)

Embrace Spontaneity With a Wet Underpainting

Over time many artists become technically adept at a variety of painting techniques. As a consequence, their work may become predictable and safe. A wet, loose underpainting can add some spontaneity to the process. Instead of acting as a rigid representation of the scene, it becomes a soft intermingled interplay of the elements of the painting. These underpaintings are more dreamlike, providing a foundation upon which the structure and reality of the scene is to be built. The underpainting is meant to be something with which the artist interacts—not just something to be covered.

One way to loosen up and let go of some control is to create a wet underpainting, allowing colors and values to migrate. When wet, pigments often have a mind of their own, producing interesting unplanned effects. Swipes of the brush and splatters of liquids can produce additional textures, if desired. It's intuition that guides this form of underpainting, and this ability develops with time and experimentation.

Don't be frustrated if you feel confused about what to do and wind up with a mess that requires correction. Most new and exciting techniques have arisen from these chance accidents. There's nothing lost by a failed underpainting. In the worst-case scenario, it will simply require a heavy layer of pastel. In the best case, it becomes a major partner of the pastel. Let the underpainting be the dream that you build reality on top of.

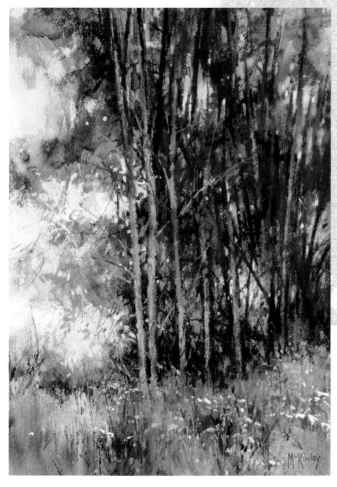

A SPONTANEOUS UNDERPAINTING

For the pastel *Textures of Spring*, I used watercolor on Wallis sanded paper to create a spontaneous underpainting.

Textures of Spring, 14" × 10" (36cm × 25cm)

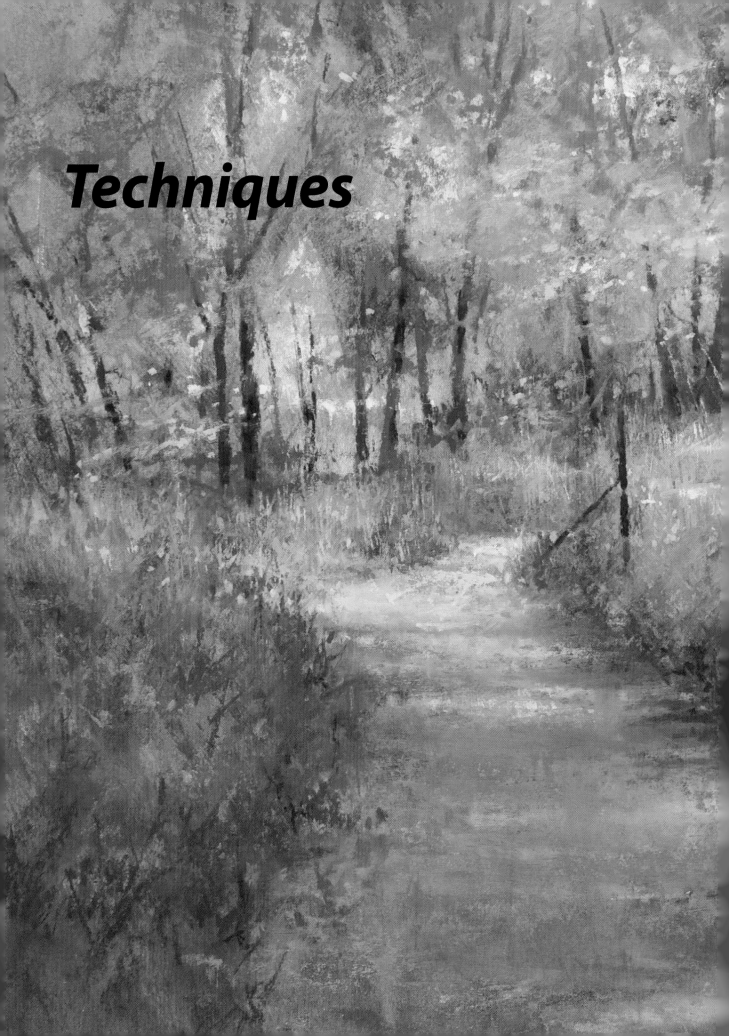

Techniques

McKinley

A Walk on the Bosque Trail
16" × 20" (41cm × 51cm)

The **Strokes** We Make

Pastel is tactile by its very nature. It's the closest thing to dipping our fingers in paint and directly applying marks to a surface. When we hold the pastel stick in our hands we make direct contact with our chosen surface, bypassing the brush. This action creates heightened sensitivity. The texture of the surface and the smoothness or firmness of the pastel stick is felt. Pressure is then adjusted to deposit more or less of the pigment, creating a variety of effects. These gestures and pressures are as individual as the artists making them.

Learn from the Masters

Copy the techniques of a successful pastel painter you admire. By emulating his or her technique, you learn the artist's methods and, with practice, become comfortable with the medium. After conquering one style, try another. Just as you try out a variety of surfaces and brands of pastels to find what fits your painting personality best, so too should you explore the various ways of applying pastel.

Types of Marks

There isn't one "right" way for an artist to make a mark—some hatch; others dab; many swipe; and some drift. When hatching, crosshatching, and dabbing, hold the pastel stick like a crayon and make marks with the tip. Make all the marks one direction, varying the colors and values as needed. This creates a hatched appearance and imparts a sense of fragmented broken color and value as well as rhythm and texture.

When adding or altering a color, change the direction of the stroke, creating a crosshatched broken application. This is a good method for blending two colors together without smearing and losing the freshness of the application.

Next try dabbing the pastel stick to create a variety of sizes of marks from small to large. For a painterly appearance, break your pastel sticks into smaller pieces and utilize the side of the sticks in a swiping motion to simulate the action of a paintbrush.

Experiment with a variety of pressures, sometimes making definite marks by lifting and setting the stick back down in various directions and then allow the stick to stay in contact with the surface while dragging. Focus on gaining tactile experience. With time, your personal calligraphy will become evident, making your work uniquely your own.

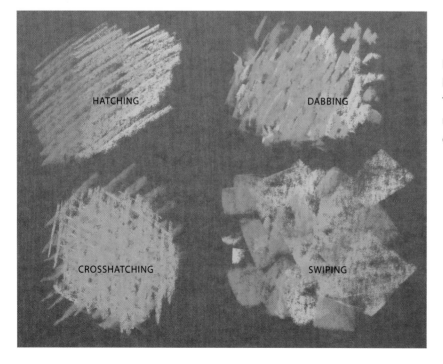

HATCHING

DABBING

CROSSHATCHING

SWIPING

DIFFERENT STROKES FOR DIFFERENT FOLKS
This example illustrates four of the most common methods of pastel application: hatching, crosshatching, dabbing and swiping.

Rubbing Pastel

To rub or not to rub is a personal artistic choice. The physical action of pushing, smearing and rubbing pastel creates a soft, ethereal quality often associated with the medium. A softened appearance can strengthen the finished statement and serve the purpose of an underpainting. Though just as wet paint worked with a brush produces a soft, melted appearance that can easily become muddy, so too can an over-rubbed pastel. Different surfaces, pastel brands and tools will create varied results—experiment with an array of objects to spread, smear and rub the pastel around the working surface to lead to fascinating techniques and beautiful outcomes.

Hands. When choosing a tool, many simply use the most convenient—the hands. If you do use your hands, you should employ some precautions. Sanded surfaces can be especially brutal, often leading to major skin abrasions, and you want to avoid any chance of assimilating any toxic pigments into the bloodstream.

Artist barrier creams, such as Gloves in a Bottle, are helpful and should be applied in advance of a painting session. Latex gloves are another popular solution. Personally, I've never been able to get used to the feel of gloves when painting, so I opt for the barrier creams and frequent hand washings.

Leather chamois. When using a leather chamois, you'll find that it responds very similarly to human skin. Since it becomes dirty easily, frequent cleaning is a necessity. Holding on to one corner, beat it against a rigid surface—and be careful not to inhale the dust.

Foam pipe insulation. Artist Terry Ludwig, maker of Terry Ludwig pastels, introduced me to foam pipe insulation a few years ago and it has become a personal favorite. Simply tear off a little piece (a tube from the hardware store will last a lifetime) and push the pastel around as if you were using a brush. A general softening will occur with minimal dusting.

Foam packing peanuts and plastic grocery bags. Packing peanuts, foam pipe insulation and plastic grocery bags share a commonality: They don't pick up a lot of the pigment; they tend to push it into the surface, instead of wiping it off.

Paper towels. These are a favorite of many artists and, without a doubt, Viva brand is the most popular. Once the towel is allowed to pick up a little of the pastel off the surface, it becomes a very useful tool for softening and smearing the pigment into the surface. I keep a piece in my left hand at all times and gently tap the pastel stick I'm using against it before returning it to the palette. This habit has helped to keep my sticks clean.

FINGER SAVERS

The abrasive nature of sanded pastel surfaces can wreck havoc on fingers. A plastic shopping bag, foam pipe insulation cut to size, foam packing peanuts, leather chamois or a sturdy paper towel can all prove helpful.

Texture Brushwork

Pastel has a close kinship to oil: Both are opaque and often hard to tell apart when viewed from a distance. Obviously, oil and pastel have their differences. Oil is wet and applied with a brush or painting knife, and pastel is dry and applied directly in stick form. Oil's ability to retain brushwork is its major characteristic. This brushwork becomes the signature of the artist and has been masterfully utilized over the centuries by artists like Rembrandt van Rijn, Diego Velázquez, John Singer Sargent, Robert Henri and Nicolai Fechin. The bold bravado stroke of the brush filled with thick paint imparts a sculptural appearance accenting the painting's topography. This heightens the appearance of texture and depth, creating a painterly (in the fashion of paint) appearance.

Pastel, being applied by the stick, doesn't easily produce the same qualities. It goes on solid, only appearing to have texture when interacting with the ground it is placed on. As artists like Degas began to push the medium beyond the realm of sketching and into fine art, they experimented with a variety of textured grounds, producing painterly results (check out some of the ballerina paintings of Degas to see how masterfully he utilized the texture of the ground).

Today's artists are still experimenting with textured grounds, producing the appearance of bold, bravado strokes that have as much visual power as the finest oils. Modern acrylic mediums have made this task easier and more archival, allowing heavy textured buildups that retain a degree of flexibility and are non-acidic.

Manufacturers like Art Spectrum, Lascaux, and Golden Artist Colors provide a series of pastel grounds that are ready to apply. Some artists prefer to make their own by combining an acrylic medium with grit (pumice powder or marble dust are widely used for this purpose). Depending on the thickness of the ground, a heavy or light brush texture may be produced. Hog-hair bristle brushes work well, imparting the same "swept" appearance as they do for the oil painter.

Whichever pastel ground you end up choosing, it will need to be placed onto a suitable surface. Make sure it is sturdy and pH neutral (non-acidic). Experiment with different strokes and find which best suits your individual style. Then get ready to deal with the comment, "I can't tell your pastels from your oils."

TEXTURED GROUNDS PRODUCE A PAINTERLY EFFECT
A close-up look at a heavy brush-textured ground with pastel raked over the top.

Hard vs. Soft **Edges**

Painting is but an illusion. How we handle the elements within the framework of the painting relate visually to the viewer and communicate our intentions. How edges are manipulated can be one of the strongest tools we have in conveying focus and form.

Conveying Form on a Flat Surface

The sculptor creates within the realm of mass, producing bulk and relating form. The painter, on the other hand, works on a flat surface and produces the appearance of form with the visual elements of shape, value, color and edge. Our pastel surface is flat. We have to produce the magic of making it appear dimensional. Hard, sharper edges produce stronger focus and flatness. Soft, blurred edges produce less attention and more depth of form. Finessing hard and soft edges throughout our paintings can lead to more attention and depth.

Edge Placement

The relativity of edges throughout a painting is determined by the artist's choices. Something may appear very soft in one painting and yet appear hard in another, depending on how the edges are handled comparatively. If an artist chooses to work very sharp-edged, then anything slightly blurred will appear very soft. If everything is blurred, anything slightly hard will appear sharp. Generally speaking, creating harder edges near the area of interest, or major focal points, leads the viewer to a specific area and holds their attention, just like focusing our vision on a given area makes it appear sharper. Conversely, softer, fuzzy edges diminish and become less important, which leads to a feeling of bulk due to the offset placement of our eyes. Softer-edged objects within our paintings feel as if they could be hugged.

Orchestrating between hard and soft edges becomes a personal style choice. Understanding their visual power provides us the power of the illusion: producing both focus and bulk. Another magician's trick exposed!

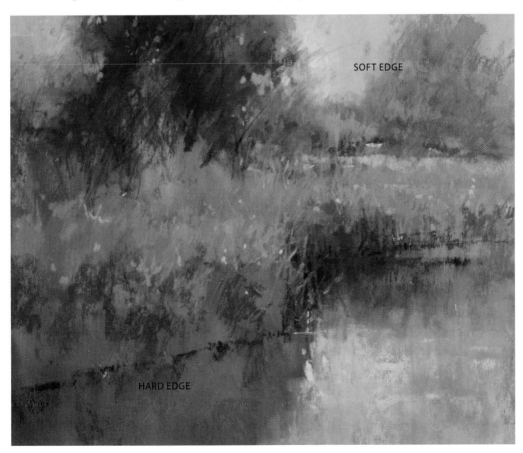

SOFT EDGE

HARD EDGE

SUGGEST DEPTH WITH EDGES
Manipulating the edges of objects that have form and depth within a painting is a powerful tool. Edges rarely convey the identity of an object. The general shape, value and color will do that. By altering between lost and found edges throughout a scene the viewer is allowed to travel in and out instead of merely from left to right, providing heightened depth.

Layering Using Hard to Soft Pastels

When painting in oil alla prima, meaning "all at once," one must work thinly in the initial application then work up to heavier layers as the painting progresses. With each layer of application, the volume of paint becomes heavier and thicker, gently interacting with the one below. This layering process can easily be mimicked in pastel by beginning with harder pastel sticks in the initial block-in stage and progressively working toward the softer brands for the final layers. This is a good way to avoid a muddy painting. Also, if you tend to have a heavy hand when applying pastel, working hard to soft is a good solution for achieving vivid colors and bold color mixtures.

Using Fixative Between Layers

One way to retain control while layering pastel hard to soft, is by applying layers of fixative to settle and solidify the pastel before applying additional pigment. If you prefer softer pastels and wish to work in layers, the initial pastel application can be rubbed or scraped down—another technique employed by our oil painter friends—to allow for subsequent layering. Depending on the support, this can be an effective means of producing bold painterly pastel paintings that have as much substance and visual weight as an oil painting.

Selecting Pastels

To make things easier when selecting pastel sticks for those beginning strokes, many artists segregate their harder pastel brands from the softer pastel brands. This works especially well in the studio where multiple palettes of pastels can be arranged. When working en plein air, it can be cumbersome to carry two palettes, so there are two ways that might prove helpful working hard to soft. First, select harder sticks for the darker regions of the palette, since typically, our first strokes are in the darker, dull shadow areas of the painting. Having more of these darker, harder sticks in our palette makes it easier to utilize the softer, brighter, lighter sticks as the painting progresses. You can also take one section of your palette box and segregate a selection of harder pastels in a variety of hues, values and intensities.

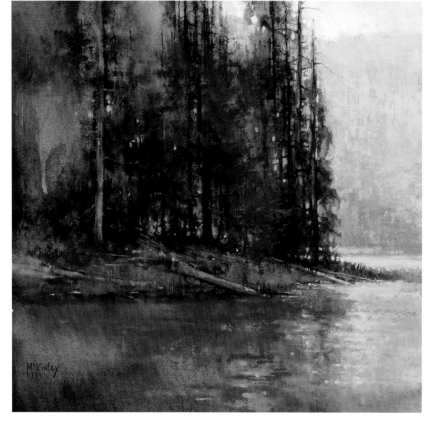

WORK HARD TO SOFT FOR GREATER CONTRAST

In *The Cove*, I smudged the pastel with my hand and a soft paper towel before applying the final strong touches to retain control of the subtle, drawn quality of the trees. A general working of hard to soft pastel also allows for a general evolution toward stronger contrast as the painting evolves. By retaining so many lost edges, I captured the feeling of quiet mystery that permeated the scene. Objects seem to float in and out.

The Cove, 14" × 14" (36cm × 36cm)

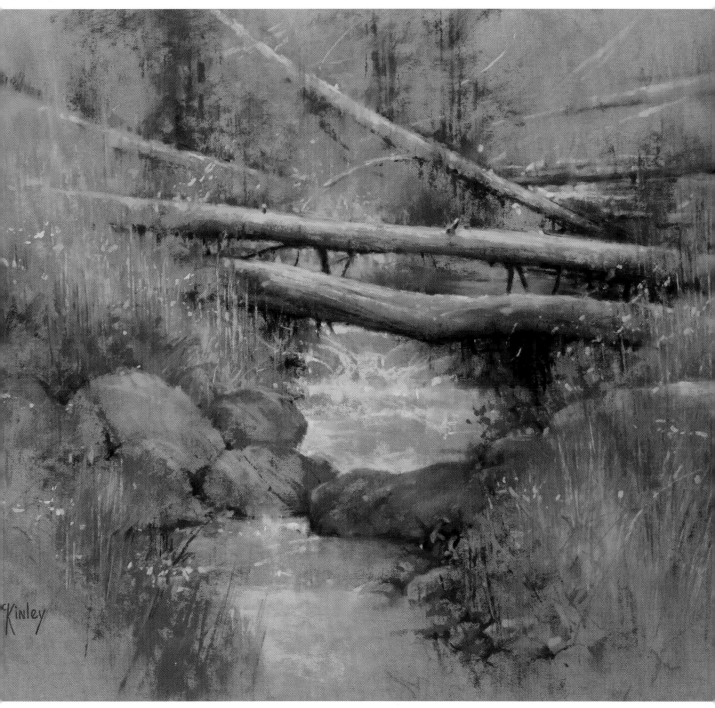

The Runoff, 12" × 14" (30cm × 36cm)

FINALIZE A PAINTING WORKING HARD TO SOFT

In *The Runoff*, I used hard to soft pastels to accomplish additional layers needed to finalize the painting. I started on location using Wallis Belgium Mist gray paper and harder pastels like Girault and I was able to come back to the studio and make the necessary changes with a few smudges and the addition of softer pastels.

Fixes for Excess Pigment Application

Although every artist has his or her own work habits, the most common technical problem is a heavy, thick buildup of pastel. When too much pigment has been applied, it becomes difficult if not impossible to proceed with the painting. Sometimes smudging or blending solves a problem, but most corrections require the addition of pigment. Before addressing necessary corrections, however, the thick layer of pastel will have to be tackled. There are numerous approaches: changing pastel brands, employing chemicals such as washes or fixatives, applying steam, removing bulk by scraping or with a brush, or deliberately smudging the excess pigment.

Different methods of correction can be employed, depending on the surface used and the brand of pastels. Ridged boards are stronger and stand up to more alterations, while thinner, frail surfaces require more care.

Switching pastels. When repairs or additions are needed, consider a change in pastel brand. Many pastelists begin with harder pastels and then migrate to the softer, buttery sticks for the finishing touches. By working from the harder to the softer brands, less pressure is required to apply a strong mark. When attempting a repair or correction, I often use softer pastels without having to rewet or spray fixative. It's always advisable to try this first.

Washing. If an area in a painting needs to be repainted or additions are needed, washing the layer of pastel will produce a receptive surface for the addition of more pigment. Each solution—odorless mineral spirits, rubbing alcohol, denatured alcohol, acetone or water—has benefits and, depending on the surface, can work well.

Some prepared surfaces use adhesives that may come loose with certain solutions. Before applying any solvent to your painting, always test it on a scrap to see if the surface you are using is susceptible to damage. A little experimentation in advance will safeguard your creative efforts.

I use an oil painter's bristle brush for washing. Nylon acrylic brushes are available, but I prefer the stiffness of a bristle brush. When washing an area or an entire painting, I sometimes leave it in the vertical position, allowing runs and drips, which could cause serendipitous "accidents." Otherwise, I lay the painting flat. Before applying anything wet to the paper, you should make sure it's tightly attached to a rigid board or some wrinkling might occur, especially with water. For this reason my paper is always premounted.

Wetting a pastel is similar to an oil painter's technique of brushing an area with a little solvent before reworking. You achieve a receptive surface for reworking with pigment that mingles with the subsequent application, producing an exciting underlayer that has often led me in a new direction with a painting.

Note that when the paper is wet, colors will look considerably darker and richer. Pigments will also merge, so expect the

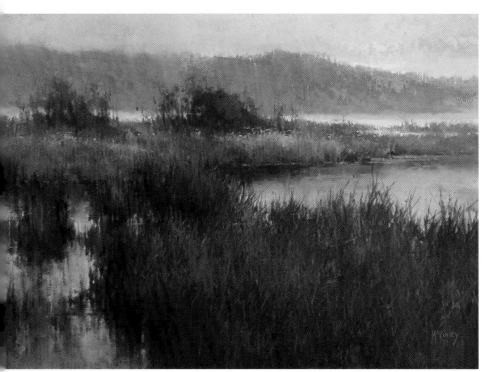

WASHING AND STEAMING

To finalize this painting, done on Wallis white museum paper, the foreground had to be resolved. Breaking the foreground land mass into a marsh instead of solid ground helped with the compositional movement by creating an entrance to the midsection. To facilitate these additions and corrections, I washed the initial foreground pastel with mineral spirits using a bristle brush and blotting with paper towels. As more pastel was added throughout the painting, I would occasionally apply steam to bind the thicker pastel to the surface. This solidified the layer, allowing for more pastel application.

Water's Edge, 12" × 17" (30cm × 43cm)

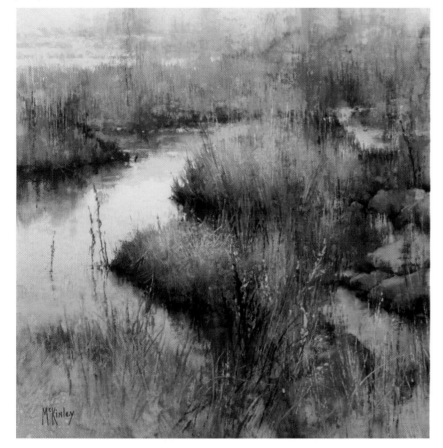

Quiet Reflections, 16" × 16" (41cm × 41cm)

SMUDGING AND STEAMING

Purposefully smudging the pastel into the ground allowed me to add stronger notes of pastel on top. Gentle applications of steam helped in settling the pastel dust onto the surface thus allowing additional marks of pastel to be applied. These few final splashes of pastel were easily accomplished with the use of the softer brands.

washed area to be somewhat duller once it's dry (I keep a small hair dryer next to my easel to accelerate this process). Once the surface is dry, you will have regained tooth and can easily apply more pigment.

Note that this technique is extremely useful for massing in dark areas. Instead of using half a stick to darken an area, try applying a little dark pastel and spreading it around with a solution. Allow it to dry, then proceed with the painting. The darks then have a wonderful translucent quality so useful to overpainting.

Using fixatives. Fixatives cause the gradual solidification of the underlayer of pastel, allowing for fresh pastel to be applied on top. They have been in use for a long time and have been applied by many great pastel artists. They were once applied with atomizers, but now we use the convenient aerosol spray can. Fixing agents have evolved from resins that were prone to yellowing to the more modern acrylic products of today. I recommend using only the finest products available from reputable art manufacturers, particularly those who cater to the pastel community. Each brand has its own character, so try a few before committing to one. Refer to pages 24–25 for more information on fixative techniques and brand recommendations.

Steaming. Because the binder in pastel sticks is water-soluble, a light application of steam can help adhere the outer layer of pastel, making it easier to apply more. The application of steam helps in dusty, heavy areas that need an additional mark or two for correction. Portable travel steamers work well, but always test the output before application because it may drip, creating new problems.

Scraping. Depending on the paper or ground you're using, a gentle scraping can create a receptive surface for reworking. A flat-edged oil painter's palette knife and a straight-edge utility razor blade both work well. Make sure the painting is in an upright or slightly forward-leaning position so that the dust falls into a trough below and not down the front of the painting, leaving a trail of pigment. Holding the edge of the blade lightly against the surface at a 45-degree angle, use a gentle downward stroke. The image remains as a ghost of its former self. By removing the thicker layer, more pigment can be applied.

Brushing. Similar to scraping, a stiff, dry brush can be used to remove much of the outer layer of soft pastel. Unlike scraping,

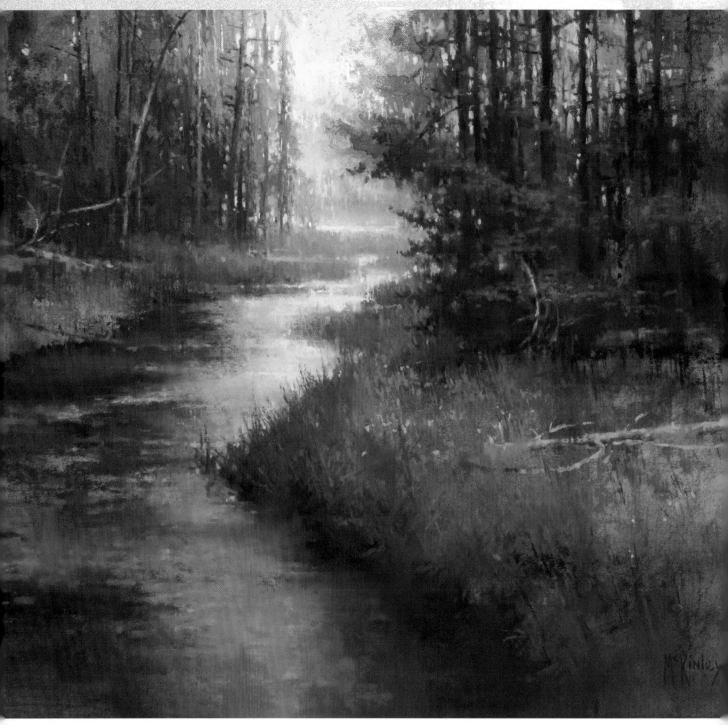

Alpine Rhapsody, 15" × 18" (38cm × 46cm)

TURN THE PAINTING UPSIDE DOWN FOR A FRESH PERSPECTIVE

Alpine Rhapsody started as a painting of a cliff next to a pool of water, but I abandoned it after a few days of frustration. Repeated washing of the mounted Wallis white museum paper with mineral spirits and blotting with paper towels left a soft, ethereal under-stain. I turned the paper upside down to lose any sense of the previous painting and started anew. At points throughout the painting, I smudged the pastel either with a soft towel or my hand, creating a soft receptive area to which more pastel could be applied.

however, the brush will blend the pastel and create a soft outer layer. One negative is the airborne dust created by the brushing action. Be sure to do this in a well-ventilated area and wear a mask, if possible.

Smudging. Smudging or smearing is a pastel technique that can also create a receptive area for the application of more pigment. Although some artists use their hands, be cautious: Many pigments are toxic. Be sure to wash your hands often. You may even wish to use surgical gloves. Chamois cloths, paper towels, foam packing peanuts, and small strips of foam padding—all are potential tools for rubbing the pastel pigment around.

When to Stop

This old adage is a good one to remember when it comes to the repairs, corrections, or resolutions of pastel paintings: Often it is best to leave well enough alone. No painting is perfect—it may only skirt the initial concept or come up a little technically short. It's often better to attempt improvement on the next painting than to continue making repairs and lose what merit we had in the original attempt. Hold on to what was working and make those small corrections only when you're sure of their benefits. A painting is what it is, and sometimes it's best to just accept that. With sound methods and retrospective evaluation, hopefully a pleasing resolution awaits.

Common Problems and Simple Solutions

PROBLEM: **Too much pastel**

SOLUTION: *Use harder pastels in the beginning and finish with softer brands. Once you acquire more control over "touch" (the ability to control the pressure of the pastel application), you may decide to work solely with the softest pastels.*

PROBLEM: **Too dark**

SOLUTION: *Pastel is an opaque, dull-surfaced medium. Purposely start with darks that are one to two values lighter than you would with a wet medium like oil. Too much dull pigment creates a lifeless painting, so allow your pastels to be a degree higher in key.*

PROBLEM: **Too light**

SOLUTION: *When pastels sticks are manufactured, white is added to the base pigment, making lighter tints. In wet painting such as oil, we add white sparingly and wisely. Otherwise we end up with chalky, cold paintings. Try to use warmer tones as things get lighter in your pastels; see if that better relates the sensation of light and helps relieve the chalky look.*

PROBLEM: **Muddy color**

SOLUTION: *We all love color and we're often guilty of overkill by placing all we can in our paintings. Determine which color dominates the mass in an area and stay close in relationship to the original color family. Avoid the same chroma when using two different colors—allow one to be brighter. Gray can be beautifully warm when placed on something cool and vice versa. Two opposing colors of equal importance will battle for attention.*

PROBLEM: **Hard-drawn edges**

SOLUTION: *Because of the stick format, pastel can easily become a drawing medium. It's fine to use many strokes or the drawn line to communicate your intent, but one of the strongest elements of a good painting is how edges are handled. If you prefer strong, hard edges, allow for a few softer, slightly smudged spaces as a counterbalance and to heighten the feeling of depth and form. Conversely, if your hand lends a soft, ethereal edge, a few bold lines will give definition and attention to an area.*

Surface **Consistency**

Achieving continuity between different areas in a painting that are vastly different in character can present a quandary: Aren't some areas greatly different in texture, like the side of a house and the surrounding trees? Shouldn't they be painted differently to represent that difference?

Indeed, the appearance of the sky is much softer than the trees, and the skin of a youthful face smoother than the hair. While this is certainly true, we have to consider the nature of a painting; it's a window into a universe of the artist's making. And, to be believable, there has to be a degree of harmonious cohesion.

In the consideration of how painters approach the separate areas of a painting, there are basically three aesthetics. The first is the decorative attitude. It tends to apply a different technique of application to each area. Consider the "magic" television painters. The sky in their paintings was brushed in with a large soft brush; the trees pounced with a fan brush; and the rocks applied with a painting knife. Even though they are all made up of similar paint and have value and color consistency, they exist without shared application.

The second attitude is the application-consistent artist, which is the opposite extreme of the decorative. These painters choose to use the same repetitive stroke of product application to create visual consistency, leaving the visual play of value, color and subject matter to tell the story. Think of Renoir using the same cupping stroke to apply all of his paint, yet we see the children at play in the park. The paint, or product, is not the element that grabs our attention. It is widely believed that the French Impressionists used this method to separate themselves from the bravura paint applications of their predecessors.

The third attitude is a bridging of the two mindsets. The artist may employ a wide array of product application and technique, but never isolates any given area. A sky may be dominated by soft applications but a few bold strokes will appear in the clouds, uniting it with the heavily painted textured trees. Since softness recedes and heavy texture comes forward, most of these painters use a variety of applications throughout the painting to heighten the appearance of depth. Areas are not singularly painted. Visual continuity is created through technique repetition, letting us believe that everything exists within the same visual space.

COMBINE TECHNIQUES FOR VISUAL CONTINUITY
Seek out a balance of repetitive strokes and technique variety for successful surface consistency.

Sentinel of the Lavender, 12" × 10" (30cm × 25cm)

Salvaging a **Surface**

Even with the best efforts, some paintings just don't work out. Whether due to an unclear concept, poor composition, faulty drawing, bad value relationship, lack of color harmony, or a combination of these, nothing we attempt can resurrect it from the mountain of failed attempts every artist produces. So when a painting just doesn't work out, is there a way to salvage the surface?

Depending on the surface, most of the pastel on a failed painting can be removed, allowing for a fresh layer to be applied. To avoid inhaling the dust, however, it's best to avoid brushing off the pastel. If extremely heavy layers of pastel need to be removed, place a trough under the bottom edge of the upright painting. Gently drag a painting knife or flat-edged utility blade down the surface, allowing the dust to fall into the trough. The best way

to remove further pastel dust is to make it wet and use a blotting action. But before you do, consider what the surface can tolerate: Water can swell and leave a thin paper or surface wrinkled; alcohol can soften certain binders used to adhere grit to a surface; and mineral spirits can soften certain glues used to mount paper to a backing board. Experiment on a section before committing. Once you feel secure in your choice, lay the painting flat, wet a section and blot the pastel off. Do not rub, as this will inevitably leave fuzz from the rag. This wetting and blotting procedure can be repeated as much as needed until the pastel is lifted off the surface, leaving the paper stained.

Good quality papers and surfaces can take quite a beating. Artists have described placing them under a faucet in their bathtubs or even taking them outside

and spraying them off with a garden hose. Whatever works! You'll notice that certain pigments stain more than others. To avoid the distraction of the ghost image stain, turn the paper upside down so it is not recognizable, and then begin anew. This often leads to interesting possibilities. From something failed, something exciting may arise, and a dollar was saved.

SURFACE RECLAMATION
Repeated water soakings of this mounted Wallis paper and dabbing with strong paper towels reclaimed the surface for another day of painting. The stain produced from the process provided creative possibilities.

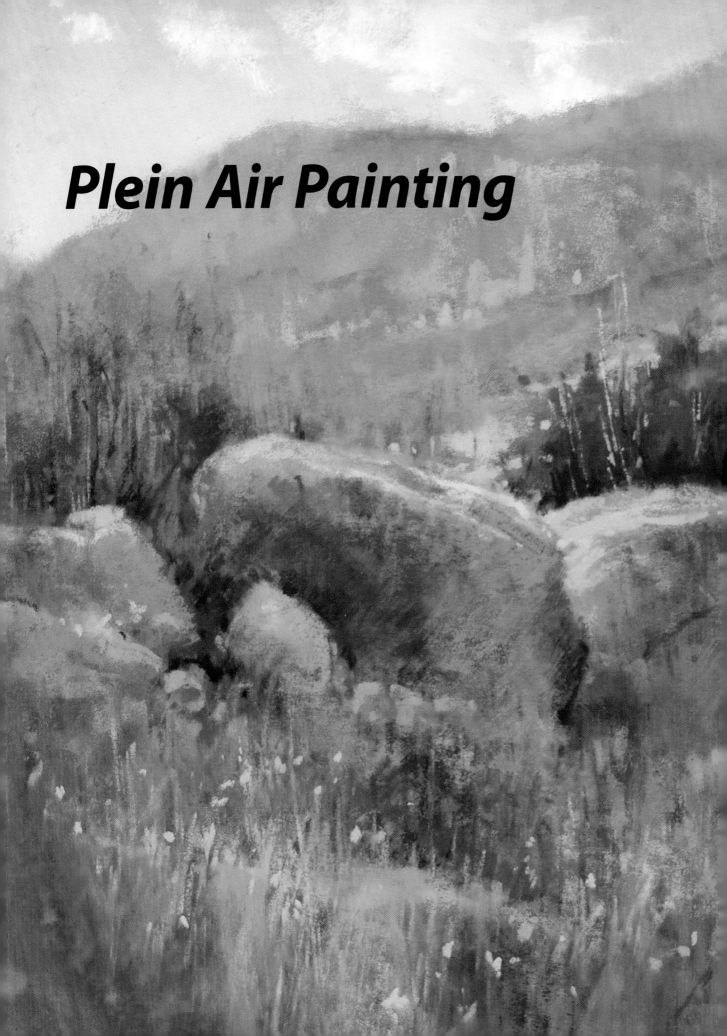

Plein Air Painting

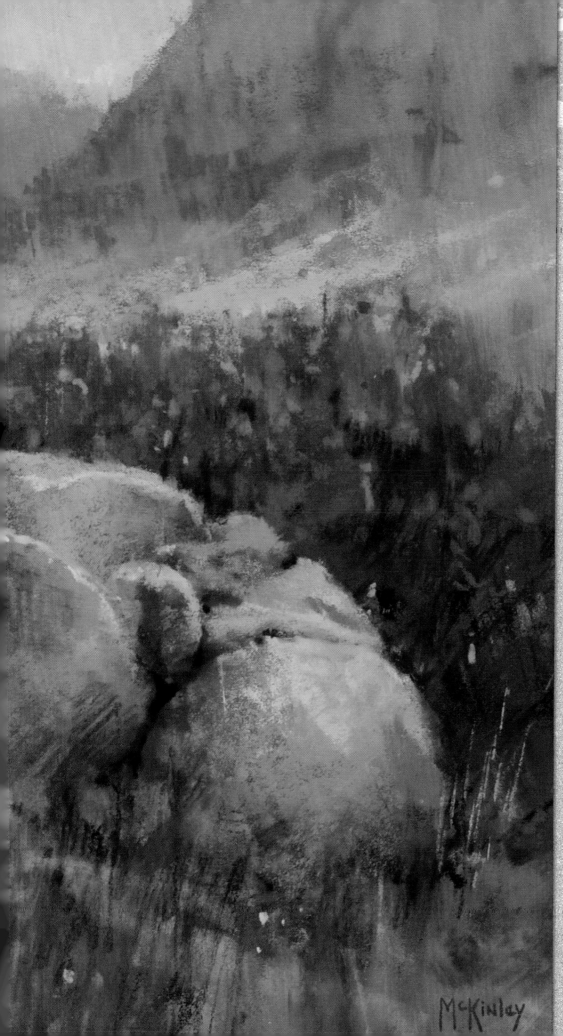

6

Stones of the Sandia
12" × 18" (30cm × 46cm)

McKinley

Plein Air **Tools**

Before attempting to paint en plein air, it's important to have your supplies organized, which will help you get into a familiar and easy routine when it comes to setup. Let's discuss the basic supplies required for a plein air painting excursion.

Item 1: Easel

The first thing you need is an easel. Artists are always looking for the perfect model—the one that will make everything easy and weigh nothing. I like to have as many pastels as possible with me and, because I'm tall, I require an easel that's sturdy enough to hold the support at a decent height. Currently, I use one of three setups, depending on the situation:

Setup 1: Using a full or half French easel is one of the most traditional. The open drawer will securely hold a medium or large box full of pastels. I secure it to the easel with a bungee cord for peace of mind. Since French easels have storage space in the drawer or under the drawer,

depending on the model, you can carry incidentals such as drawing pencils, a small watercolor palette, brushes and other miscellaneous items. Of course, this can become a heavy setup to pack around for any long distance.

Setup 2: The MABEF model M27 easel, which has two retractable support arms, will securely hold up to a medium-size case of pastels when extended. Though not as stable as the French easel, it weighs much less and allows for greater mobility when choosing to paint at a greater distance from your car.

Setup 3: This setup utilizes an all-in-one model. The one I have had experience using is the Artwork Essentials EASyL-Versa Pastel Case. It holds the pastels and has a lid designed to function as the painting support. These setups require a sturdy camera tripod; a professional photographer's model is well worth the investment. Many have interesting and handy attachments, such as a tray for extra pastel sticks

and a strong shoulder bag—some even come with a wine glass attachment.

Item 2: Pastel Case

Since pastel sticks are fragile, it's imperative that you have something secure and portable in which to carry them. There are records of early artists using pastel as a field-sketching medium, but it has really come into its own with the introduction of strong portable boxes specifically designed for field painting. It wasn't that long ago that artists either made their own or relied on a crafty friend to build something that could hold up to the rigors of on-location work. Demand has certainly pushed the process, and it seems there are new systems being introduced all the time.

Two versions I've used with considerable success are the Heilman Designs Pastel Box and the Dakota Universal Travel Box. Both are made of wood and fold in a briefcase style, allowing pastels to be stored in both sections (I always secure the box to

HALF FRENCH EASEL SETUP
For this workshop demonstration in Minnesota, I used a half French easel setup.

Photo by Garry McMichael

my easel before taking the individual lids off the sections). For transporting these cases, a large laptop-sized shoulder bag works well and allows for additional items to be stowed. The bag makes packing on location and portage through an airport much easier.

Item 3: Umbrella

The third item you'll need is an umbrella. When setting up, try to keep your painting surface and pastel case in the same light. Since direct sunlight is so intense, it's better to work in a shaded situation whenever possible, using an umbrella if necessary. If you must work with the sun striking either your pastel case or surface, be sure to compensate for the intensity; otherwise, your finished painting will be too intense in color and often extremely dark.

When selecting an umbrella, avoid brightly colored umbrellas, since they cast a color onto your work, which affects your color choices. Recently, manufacturers have made portable, neutral-colored clamp-on umbrellas. This makes working in constant shade a lot easier. But watch out for gusts of wind. A high wind can spell disaster if your pastel case goes flying and you spend the remainder of the day picking pastels off the ground. One way to better stabilize the situation is to weigh down your easel with something heavy, such as a sack of rocks. I've also had good results using an umbrella from Artwork Essentials that lifts off in severe wind.

Item 4: Miscellany

Some additional miscellaneous items to bring along are: extra pastel paper for another painting; a sketchbook for thumbnail composition sketches and notes; a

MABEF M27 EASEL SETUP
At a demonstration nearer home, I used a MABEF M27 Easel setup.

Photo by Elloie Jeter

ALL-IN-ONE EASEL SETUP
An artist-friend of mine, Willo Balfrey, paints in northern California with an All-In-One Easel setup.

Photo by Willo Balfrey

small digital camera to record the scene and document the stages of the painting; a small watercolor palette for possible underpainting techniques; a few oil bristle brushes that can be used for removing heavy pastel and wet pastel techniques; Viva paper towels for smudging of the pastel and cleanup; a small secure container of mineral spirits for spreading the pastel if needed; a few 2B or HB drawing pencils for sketching and drawing; a good wide-brimmed hat to shade your eyes; water; bug spray; and sunscreen. Some of these can be stored inside a French easel or in a small backpack. Learning how to travel light but still have the things we need is an ongoing process. If you haven't used something in awhile, remove it and lighten the load.

Once you have a sturdy and dependable system in place, you can relax and begin exploring your approach to the subject matter. Then you'll discover how working with pastel on location is a rewarding process, one that facilitates immediate and spontaneous applications of pigment to surface.

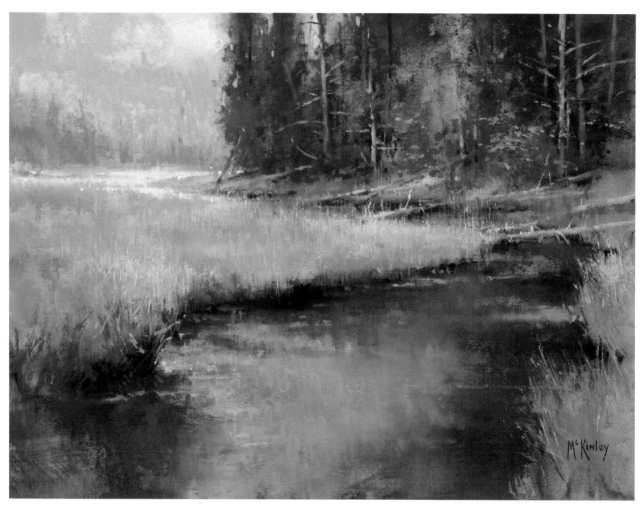

October Morning, 12" × 16" (30cm × 41cm)

PLEIN AIR BY CAR ALLOWS FOR VERSATILITY

When I painted *October Morning* on location in the Cascade Mountain Range, I had my car, so I took a full French easel and a large Heilman box. This setup provided the comfort and stability, nearly, of a full studio while standing in one of the most beautiful locations I know.

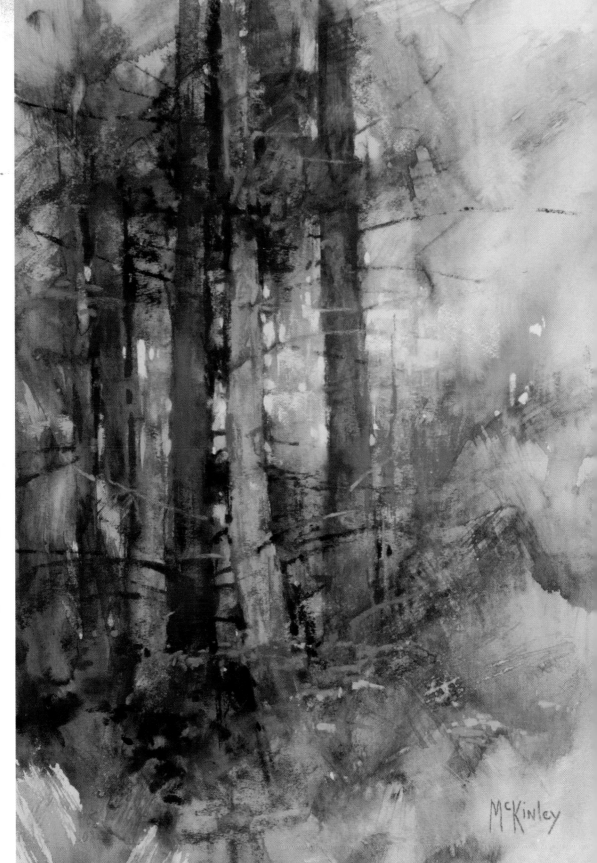

PLAN YOUR SETUP AHEAD

Be aware of how much you can carry before heading off on a painting adventure. What may seem doable in the moment can become unbearable after a long day of painting. For *Among the Pines*, I opted for a more compact setup, so I'd be able to work farther from my vehicle.

Among the Pines, 14" × 10" (36cm × 25cm)

Field **Sketching**

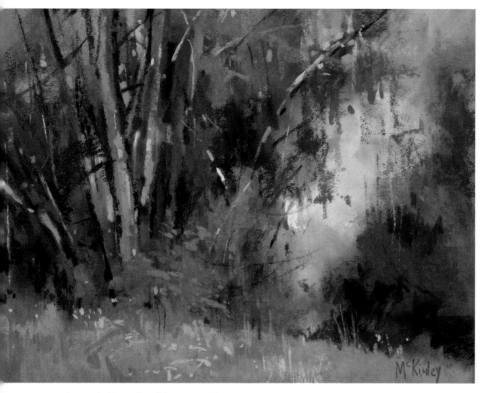

Among the Trees, 9" × 12" (23cm × 30cm)

A FIELD SKETCH
This field sketch took approximately one hour to complete. It caught the attitude of the scene, capturing the large shapes, value relationships, color harmonies and textural rhythms.

Field sketches represent the tactile connection to the subject matter—that bit of reality—and can then be used as reference back in the studio. By deciding to work in a quick sketching mode, you'll find the pressure to perform is diminished, making it easier to capture something interesting. These sketches can then be used as reference and motivation for a studio rendition.

Think of a plein air sketch as a chance to capture the essence of a scene in a way that relates more closely to the way in which the human eye and mind interpret a scene. Don't worry about completing a field painting. Accept it as a reference.

Allowing yourself to sketch isn't as easy as it sounds. You have to let go of the notion that you must leave with something praiseworthy or frame-worthy. Keep reminding yourself that the reward will come in the future when your studio painting is enhanced by your having worked from life.

The Field Sketch as Modern Art

Historically, French artists like Jean-Baptiste-Camille Corot (1796–1875) and Charles-François Daubigny (1817–1878) and Hudson River School painters like Frederic Church (1826–1900), Albert Bierstadt (1830–1902) and Thomas Cole (1801–1848) all utilized field works to paint their larger studio renditions. Most didn't consider these works to be finished paintings so they were left unnoticed in the studio. Many modern art critics, however, find the field sketches superior to their polished studio paintings, and now these sketches are being recognized as major works and have found homes in many museums.

On-Location Start to Finish

One plein air approach is to start and finish on location—to be one-on-one with the subject, creating a spontaneous and intuitive reaction to the environment.

It was during the Impressionist movement in the nineteenth century that the idea of starting and finishing a painting on location took hold. Artists realized that working intuitively created a more honest statement than when they allowed themselves the luxury of the studio. Based on good training that produced good intuitive skills, these paintings have a spontaneity about them. Because light changes so quickly, it became important to work no more than three hours on a painting. Those needing more time would return at the same time of day, picking up where they left off.

The finish-on-location painter needs to understand that it takes a lot of practice and training to be able to respond to nature. Artistic intuition is not a gift but something that needs to be cultivated and given time to mature. When you watch an artist produce a beautiful painting in a couple of hours, it's because they've worked at it. For every success, there have been many failures. Trusting these intuitive notions when working on location can help back in the studio, allowing us to ignore our prejudices and produce more spontaneous, heartfelt work.

FINISHED ON LOCATION

Layers of Light, which I started and finished on location, took approximately four hours to complete. After two and one-half hours, I turned the easel away from the scene, allowing the final adjustments to be what the painting needed, instead of what the scene dictated.

Layers of Light, 10" × 14" (25cm × 36cm)

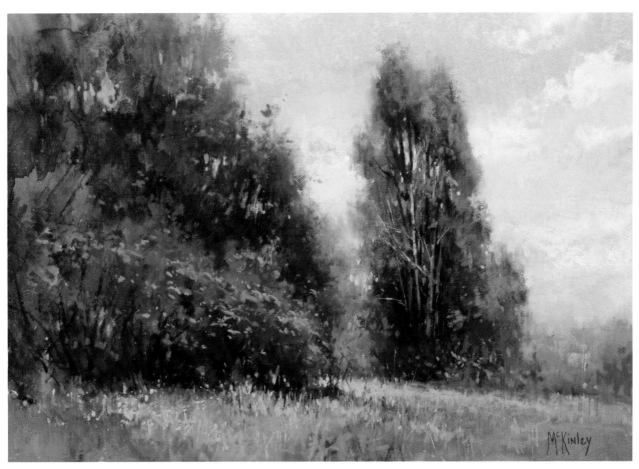

A Studio **Finish**

After working for a period of time with both the field-sketch and finish-on-location mind set, many painters discover that what works best is to begin on location and finish back in the studio. By starting directly from the source of your motivation, you gain sensitivity for the real light and a real connection to the scene. Your inspiration is from something alive and your choices are based in reality.

Finishing back in the studio allows for fresh analysis away from the influences of the constantly changing scene. You'll be rested and better able to view the painting with fresh eyes. It's easy, for example, when working on location, to see too much—to concentrate on the scene and fall in love with every square inch, producing muddled works that lack a clear statement.

In the beginning of the painting, it should be all about the scene. Pull from the location what information and influences you need, but know that, in the end, it's all about the painting. A painter has to orchestrate and manipulate these elements to produce a successful finish. By physically removing yourself from the influences of the scene, it becomes easier to listen to the painting and hear what it's saying.

What I hope to accomplish when working en plein air is a good start. I remove the pressure of finishing and allow myself the luxury of working like I have all the time in the world, even though I know otherwise. At the end of the two- or three-hour period, I step away. Sometimes the result is a field sketch, which might influence a studio piece, and sometimes it's a finished painting, which is a bonus. If not, I put the painting away to be evaluated and adjusted back in the studio.

At other times, I simply turn my easel so that I'm no longer looking at the scene. In effect, this is like working in the studio even though I'm still on location. But it helps me make it about the painting—and to listen to it for guidance.

If you make the effort to take your equipment out on location and work directly from the landscape, you'll be repaid with field starts, some of which may lead to studio reevaluations, and sometimes with intuitive plein air finishes. Whatever the result, the endeavor will contribute mightily to your painting skills, and besides, it's totally addictive.

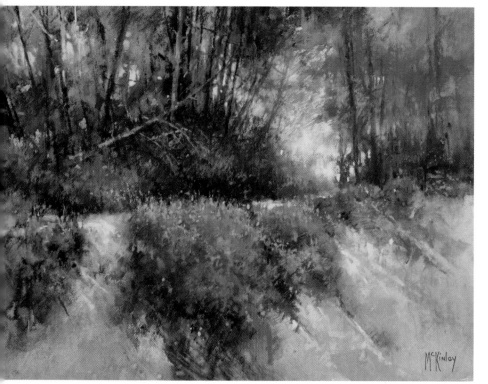

LOCATION START, STUDIO FINISH
I started *Edge of the Bank* on location. After working for two hours, I put the painting away. The light had changed and the motivation was gone. Back in the studio, rested and removed from the intensity of the scene, I found it easier to evaluate the painting, leading to minor adjustments that strengthened the overall unity of the piece.

Edge of the Bank, 12" × 16" (30cm × 41cm)

Tips for Transitioning From Scene to Studio

When making the transition from scene to studio, review this short list as a guide to bringing an on-location painting to a successful conclusion in the studio.

1. What's the concept? Ask yourself: "Why was I painting the scene?" If you know why, you'll know what. This question helps to reestablish what was important and what might be frivolous about the content. Since it's easy to get off track, periodically remind yourself what was important in the first place.

2. Reevaluate the composition. Where's the center of interest? Does it have importance? Do the shapes in the painting lead there? Are the strongest contrasts—in terms of edge, value and color—within that area?

3. Do the values (the light and dark relationships) work? Within the major masses of the painting, do the values relate properly? Have I unintentionally over-exaggerated the relative darks and lights within any given area, creating a value range that's too extreme?

4. Is there color harmony? Do the colors relate or fight for importance? Does the painting accurately reflect the temperature of the light?

5. Are there dominants, in terms of value, color, shape and texture, and accents that provide interest in the painting? If everything is of equal importance, then nothing stands out.

6. Does the painting have passive areas—a place where the viewer's eyes can rest? Too much stimulation produces an overly busy painting that agitates the viewer, so allow for a couple of quiet (less busy) areas.

7. Is there any mystery for the viewer to solve? A mysterious (not overly explained) area engages the imagination, allowing viewers to become involved in the painting. Let a viewer finish a few things and you'll keep his or her attention longer.

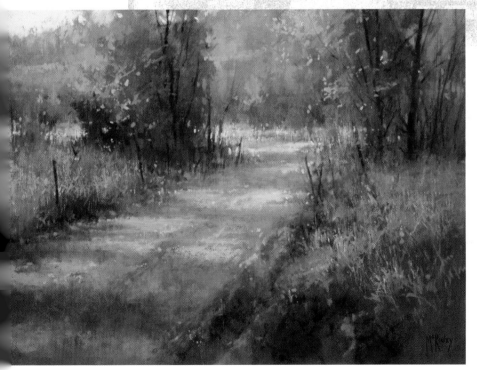

BACK IN THE STUDIO

For *Shadow Lane*, I worked back in the studio from a quick plein air sketch and photographs, which removed the pressure of capturing the light before it changed. Having the experience on location provided the sensitivity; being in the studio provided unrestricted possibility.

Shadow Lane, 12" × 18" (30cm × 46cm)

Observing **Nature**

Deciding what to paint is one of the most common dilemmas with which painters struggle. Just like hunters seeking prey, most of us are always looking for that certain subject that will motivate us to new artistic heights. This often leads us to profoundly beautiful subjects. As spectacular as many locations may be, it is often the mundane that becomes our final muse.

Simplify the Scene

Because light changes, it's important to work with efficiency and power when you're working en plein air. Detail is not an artist's friend. It's easy to believe detail holds the answers, but in fact it becomes the diversion. Simplifying what you see is a necessity. Remember, it isn't individual blades of grass that make the field rise and fall across the landscape.

Without light, we see nothing, so light falling on form is the key to communicating what we see. It's by arranging shapes and creating the form that you represent the scene to the viewer. Your goal isn't to create a painting that's polished and finessed, but rather to capture the essence of the light and the magic that captured your attention in the first place.

Ever since the arrival of photography, artists have had to fight the urge to see it as the master of what is real. There's no doubt that photography, used carefully, is a valuable tool. What limits its usefulness is the belief that it can't tell a lie. That can prejudice your thoughts more than you realize. Try to imagine what artists thought the world looked like two hundred years ago. It's difficult to do when you've never known a time without the printed picture as a part of your consciousness.

When you take photos back to the studio to use as reference, be sure to ask yourself: What is it that the camera won't capture? That's what you want to infuse into the painting.

Understand Your Concept

Color, composition, value—they all contribute substantially to a painting's outcome. Your very first consideration, though, is concept. Before you even begin to paint, ponder why you're painting the scene. What do you want the viewer to leave with after seeing your painting? Visualizing the finished painting will lead you to your painting's concept, which will guide you throughout the painting. It supplies the "why" that determines the "what" when it comes to the choices you'll make. By being aware of the concept behind the painting, you'll be able to manipulate the three other key factors—drawing, values and color choices—to strengthen your personal statement.

Your next consideration is the drawing. When composing a painting, try to concern yourself less with what to put in, and more with what can be left out. Arrange the balance and movement of the individual elements to strengthen the concept. A small thumbnail sketch will help to make sure your design works before you commit it to your surface.

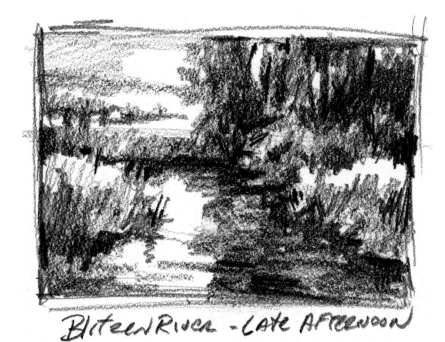

BliteeNRiver - LAte AfteeNooN

PLEIN AIR PAINTING AND THUMBNAIL SKETCH
To develop the composition for *Late Afternoon Color* (opposite page), I first did a thumbnail sketch to work out the basic design and value masses. Planning this information in advance allowed me to relax and paint as the light continued to change.

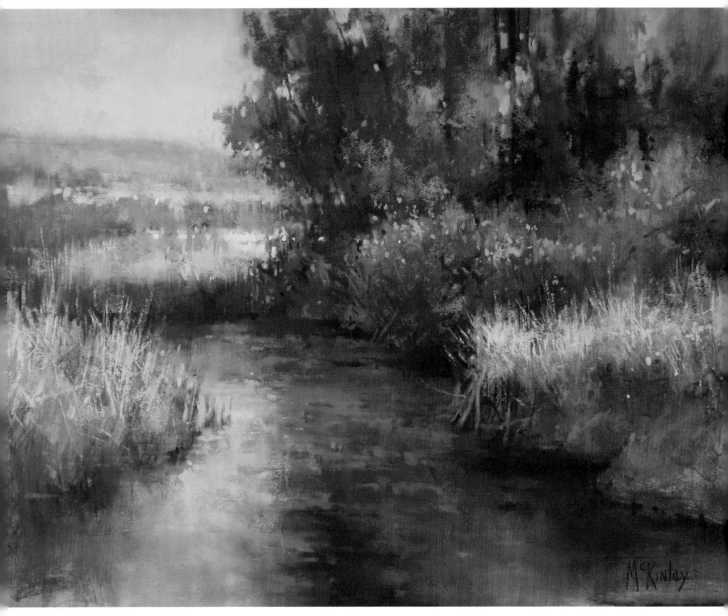

Late Afternoon Color, 12" × 16" (30cm × 41cm)

Understanding **Value** en Plein Air

After you've contemplated your concept, and before you begin, think about value. Value makes a scene believable. You can get away with a lot of color choices as long as you stay sensitive to the values involved, thus the saying: "Value does the work; color gets the glory."

Your first step is to generalize the values of a scene into no more than four basic masses, and to avoid getting too enamored with the accents within them. It's easy to see separations within these basic masses and to allow your mind to exaggerate them. This separates the general relationships between the masses and diminishes the sense of natural illumination. A small value map, using just four values, is very helpful. Squinting is also a great help when looking at the scene. This eliminates most of the detail and allows you to see a general value mass.

Value Range

Value range is a strong element of what we experience outdoors. Most artists are taught to associate a scale to the degree of value they see, or the amount of light on a surface. The scale uses 0 to represent black (void of illumination, nothingness) and 10 to represent pure energy (the highest reflection of light), with a mid-value considered value 5. In softer light, this works well, but under intense natural light, the scale moves up. The darkest masses (not individual accents) become closer to value 3, bringing the mid-value closer to 6½. By working hard to see this adjusted value scale, you'll be better able to represent the natural illumination experienced while painting under the sun.

Creating Color Harmony

The next considerations involve color. When it comes to color choices, the first concern is the temperature of the light. Everything in a scene shares one thing—light. When choosing local colors for the different areas of a painting, it's easy to associate a general color to things; instead, make choices that are influenced by the temperature of the light.

To achieve color harmony, be sure to compare the relative relationship of all the objects in the painting, rather than separating out single components. Because the light is common to each element in a scene, each part shares in its influence. When you relate that shared influence to each section of the painting, the result is a natural representation of the harmony you see.

0	1	2	3	4	5	6	7	8	9	10
			DARK				MIDDLE			LIGHT

A VALUE SCALE FOR THE LANDSCAPE
This value scale indicates the dark, middle and light scale adjusted for the landscape. Because of the intensity of outdoor light, the 0 to 10 value scale should be adjusted so that a mid-value falls closer to 6½ and the darkest masses fall closer to 3.

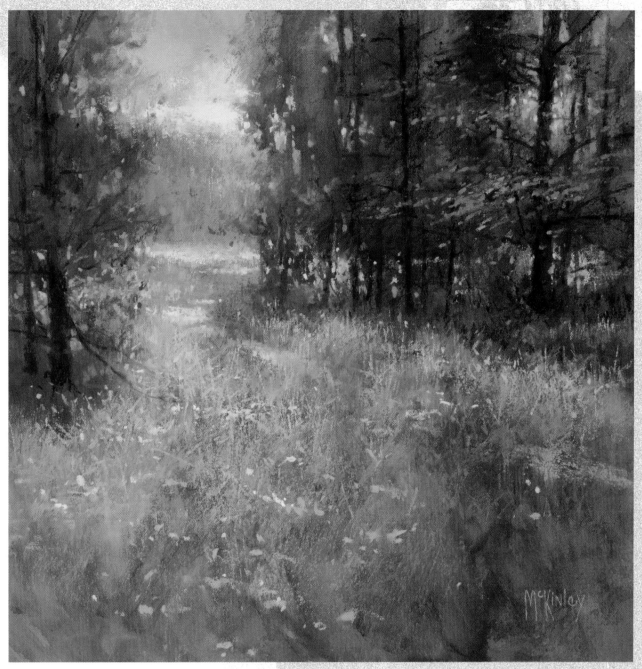

Deschutes Trail, 12" × 12" (30cm × 30cm)

FAST COLOR SKETCH EN PLEIN AIR

Creating a quick, bold field sketch can capture the essence of a location. In this case, an overcast day produced rich, luscious color saturation but a flat lighting condition. Generalizing the value masses helped give emphasis to the strongest detail in the light.

Be Consistent

Once you choose a style or technique, don't stray from it. Different aesthetics for the sky, mountains and foreground will disconnect the painting just as disastrously as mistakes in value and color. If you've learned how to crosshatch the grasses for texture and to rub the sky for softness, don't overdo both in the same painting. A work needs the continuity of a distinct personality, so refrain from using every painting gimmick you know. Allow yourself several painting personalities, but not in the same work.

Air **Travel** and Pastels

Traveling with pastel supplies can be a delicate operation, be it for painting adventures in faraway locations or the opportunity to participate in a workshop. The actual process of packing is daunting to even the most seasoned pastel painter. When traveling by car, we can bring a portable studio with us; there's ample room for multiple paper choices in a variety of sizes, an extra pastel palette, easels, umbrellas, and multiple hats (depending on the environment and your mood). Rarely are all these extra supplies utilized, but we know they're there, just in case the need should arise. When air travel is required, everything needs to be downsized to the bare minimum, providing portability.

The Pastel Case

A good sturdy pastel case for transport is a necessity. The largest pastel case I use fits into a 17-inch (43cm) laptop computer bag. The smallest case fits a 12-inch (30cm) laptop bag. It's best to keep the case as small as possible. You'll be lugging it around in the airports, through security, and stowing it in an overhead bin. What feels light around the house can become a burden after a day of travel.

Due to increased security, it's advisable to hand-carry your pastels instead of packing them in checked luggage. If you decide to check your pastel case, remember that all baggage, not just hand-carried, is scanned for dangerous content and most is inspected away from your care. To avoid a potential mess, be sure to place the pastel palette in a plastic bag that is easily opened and closed, and post a large note stating that the contents are "Fragile Artists Chalks" with instructions on how to carefully open and close the box. When traveling outside the country, make the note bilingual. Adding a polite "Thank you for your care and consideration" never hurts.

Transporting Finished Paintings

To transport the pastel paper and finished paintings on a flight, create a protective sandwich consisting of two to three Gatorfoam panels and surround this with cushioning clothing within your checked luggage. Gatorfoam is a multi-layer composite of extremely dense and durable polystyrene foam board that resists crushing and denting. It's lightweight, puncture-resistant, and also makes a good drawing board surface for your pastel papers. Stack your painting surfaces with glassine insets placed between layers and fasten the boards together with large clips available from an office supply store to stop slippage. Seal this in a plastic bag before placing it in your luggage to protect the contents from any pastel dust migration that might occur during transport. This "sandwich" rarely piques the interest of the Transportation Security Administration (TSA) inspectors, but a note describing the content is still a good idea. When ready to paint, I adhere the pastel paper to the drawing board with drafting tape, which is easily removed, yet holds well.

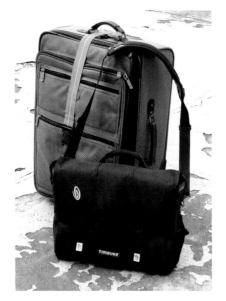

MY AIR TRAVEL SETUP

I carry a large, checked bag that contains a half French easel, my Gatorfoam pastel paper sandwich, miscellaneous art supplies, clothing and toiletries. The black carry-on bag contains my pastel palette and a few extra pieces of pastel paper in case my checked luggage is delayed in arriving—an inexpensive easel can always be found.

One-Bag Traveling **System**

Condensing your pastel supplies into one backpack can be a challenge, but well worth it for traveling far from your studio. Following is the list of major components in my one-bag system.

- **A sturdy backpack or rolling carry-on bag.** Remember that your painting equipment is heavy and often has sharp edges. A flimsy bag will fall apart before the painting trip is over and finding a replacement in exotic locales can prove difficult. Bags made for executive travel purposes are often the best to consider.
- **Small, sturdy pastel palette.** Pastels weigh a lot. A box that weighs very little empty can become quite heavy when filled with pastels. If you work with your pastel palette attached to a tripod/easel setup, you will most likely be reaching over it to work on your painting. Consider this reach before selecting a box. Dakota Art Pastels compact travel box and the Heilman backpack box are good choices.
- **Tripod/Easel.** Don't skimp on this accessory. Most camera tripods are not built for the weight of our pastel setups.

The better built the tripod, the better it will stand up to the abuses of painting. Avoid tripods that have a lot of plastic parts. They are often very flexible and easily broken. My travel tripod is a Bogen/Manfrotto 725B Digi. The ball-joint, quick-release head holds the drawing board for the surfaces.

- **Secure tray for holding the palette.** SunEden has attachable trays that fit a multitude of tripod/portable easel models. I use the Artist Shelf-400. It attaches easily to the Bogen tripod and holds either of the above mentioned palette boxes. Secure the open palette to the tripod with a bungee cord before exposing the pastel sticks. It is of note that the Heilman box comes with a camera quick release built in. This allows for the use of their supplemental easel attachment that attaches to predrilled holes in the open box.
- **Attachment for the painting surface.** I recommend flush mounting the camera quick release plate that comes with the tripod to a 12" × 16" (30cm × 41cm) piece of hardboard. This will allow you

to change positions and paint angles with ease. Paper can be taped to the rigid surface; paper can be mounted to a 12" × 16" (30cm × 41cm) surface and clipped to the board; or preexisting 12" × 16" (30cm × 41cm) or 16" × 20" (41cm × 51cm) surfaces can be clipped to the drawing board allowing for a multitude of possibilities.

- **Means of carrying painting surfaces and finished paintings.** With the addition of another 12" × 16" (30cm × 41cm) hardboard, or lighter-weight Gatorboard, surfaces and paintings can be sandwiched one on top of the other between the drawing board and the additional board. The boards create a hard-puncture-resistant outer shell. For a perfect means of holding this sandwich together, I recommend the shirt "Pack-It Folder" from the Eagle Creek Travel Gear. It accommodates a 12" × 16" (30cm × 41cm) surface very well and has four folding sides with Velcro for adjustable depth.

KEEP IT LIGHT
The drawing board with the camera quick release attached and the Eagle Creek shirt "Pack-It Folder" bag.

The Business of Pastels

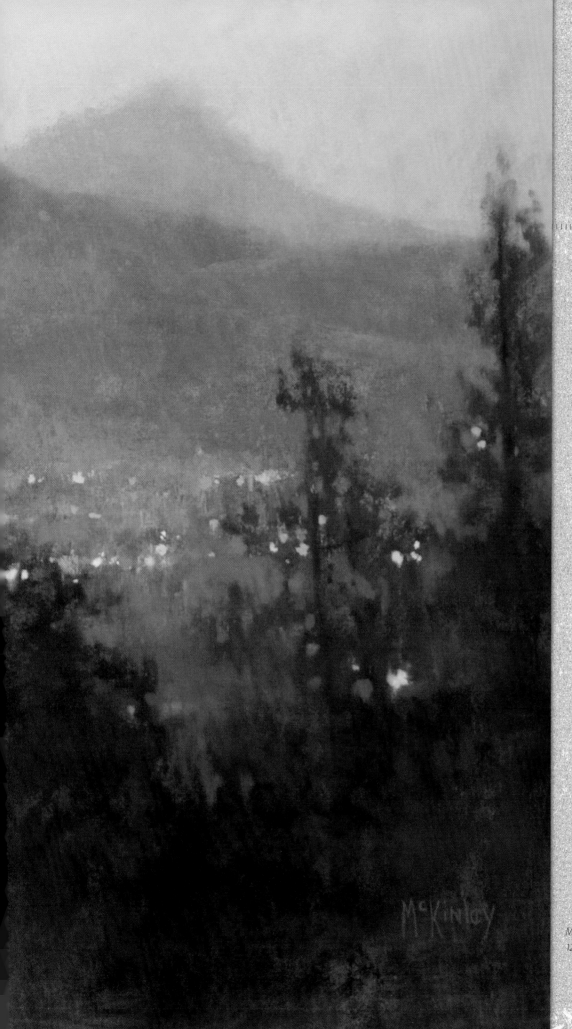

7

Magenta Dusk
12" × 18" (30cm × 46cm)

Framing

Framing your work is like choosing clothing. Depending on the task, you need to dress appropriately. I have two different presentation methods for my finished pastels: One is to use a traditional mat and frame; the other is to frame in the fashion of an oil painting. Depending on the piece, one of these options usually works well. The most important purpose of framing pastels is to protect them from damage. Unlike paintings that dry and are able to be handled with little concern of damage, pastels are fragile and are better protected when framed properly.

Choosing a Glass

Glass is almost always used to protect the pastel surface from touch and moisture. Some artists are experimenting using applied varnishes and mediums over their pastels to preserve them. Since this alters the appearance and requires advanced planning, I haven't experimented with it—yet, that is. Modern advances have given us the ability to use anti-reflection (AR) glass and ultraviolet protected (museum) glass, which greatly enhances the appearance of the painting. Once prohibitively expensive, the prices for these have come down, and many pastel artists are spending the funds for these framing products. Personally, I think it has made a difference with my galleries in terms of where they are able to display my work, and consequently, in sales.

Framing With a Mat

Since most pastel artists believe it's best to separate the glass from the pastel surface, the easiest and most traditional method has been to use paper matting between the finished painting and the frame and glass. If you choose to use a mat, make sure it is pH neutral or 100 percent rag.

Old pulp paper mats were highly acidic and over time could damage the painting. When I use a mat, I usually use a cloth-covered matting either of a raw or bleached linen variety. Instead of double matting, I opt for a wood fillet that accents the outer frame; this adds an accent as well as depth between the glass and painting. The general rule on width of mat is wider on small paintings and narrower on large ones. Traditionally, a little extra width is placed at the bottom to weight the piece.

Frame Selection

When it comes to choosing the color or value of the frame or matting, I rely on my understanding of simultaneous contrast. If I want to accentuate the darks in a painting, I'll choose a slightly lighter frame and vice versa. The same holds true for color:

A warm frame will make a painting appear cooler and a cool frame, warmer. The more neutral the frame, the more the painting will shine. Since we rarely know where our work will end up, it's best to frame simply and to showcase the painting. Leave the decorative framing for the interior decorator who understands the environment where the painting will reside.

Framing Without a Mat

Many pastel artists are abandoning traditional mat and frame presentations and replacing them instead with wide wood frames, similar to oil and acrylic paintings. This allows the pastel to look less like a print or poster, which commonly have a wide surrounding border.

The traditional mat serves as more than a decorative border; it acts as a spacer, holding

FRAMING WITH A TRADITIONAL MAT
Matting is the most traditional method of pastel presentation. Paper mats, either pH neutral or rag, have been the standard. In this example, a cloth-covered mat of linen and a wood frame fillet make for a more elegant gallery presentation.

the delicate pastel surface away from the glass. When matting is eliminated, the framing options are to either sandwich the painting against the glass (an old French method) or to utilize a spacer. Most framing experts agree that it is best to keep the pastel surface away from the glass. For this reason, I use a spacer when framing matless. Pre-manufactured spacers come in an array of sizes, have adhesive on one side, and are easy to cut to size. They make it a breeze to have a pastel ready to hang in a matter of minutes. Cut the spacer to fit the sides of the glass, peel the tape back to expose the adhesive, and stick it to the outside of the glass. Once it's attached to the glass, simply place it on top of the painting with a non-acidic, pH-balanced backing behind the painting. For added stability, seal the glass to the backing. Use pH neutral tape available from a framing supply store. Attach the tape to the front edge of the glass and wrap it around the sides to adhere it to the backing. This seals the painting between the glass, spacer and backing, allowing for easy placement into a frame and easy removal if needed.

Sealing the Frame's Edge

When finishing the back of our pastel paintings, it's wise to seal the edge between the frame and backing. This helps to protect the artwork from moisture, dust and insects. Traditionally, a paper dust cover is glued to the frame and trimmed to the edge, providing a clean professional surface. If your paintings are frequently transported, you may find an alternative product like framer's tape provides more stability when compared to the traditional dust cover, which can be easily damaged. I use an extra backing board of acid-free Fome-Cor and seal it to the frame with 2-inch (5cm) framer's tape purchased from my local art supply store. This can be removed easily, yet seals the back and provides a clean appearance.

THE OIL MOTIF

Many pastel artists have decided to go without mats in order to frame in a traditional oil motif. Small plastic spacers (purchased from an art supply or framing store) are easily attached between the painting and glass on the inside of the frame. Tucked out of sight under the lip of the frame, all the viewer sees is the outer frame and the finished painting. This framing style works best if the pastel surface is rigid or the paper has been mounted to a rigid substrate since lightweight pastel papers are prone to slipping and wrinkling.

TOOLS FOR MATLESS FRAMING

On top of a cutting mat is a spacer attached to museum glass, craft knife for cutting the spacer material, backing board, and framer's tape for sealing edges.

Trimming a Finished Pastel

Pastel surfaces often need to be trimmed to fit framing requirements or to improve the overall composition of the painting. Once pastel has been applied, this becomes a more delicate matter and requires added precautions so as not to alter the appearance of the painting.

Useful tools to have on hand are: glassine protective paper, craft knife with fresh blades, heavy-duty utility box cutter with fresh blades (for extremely rigid surfaces), metal straightedge (a metal carpenters square works well), cutting surface, drafting tape, and an emery file board. In place of a metal straightedge, a mat cutter can be used.

Start by placing a sheet of protective glassine paper over the painting, taping it to the backside or extra border of the surface. The glassine protects the surface of the painting, allowing the straightedge or mat cutter to be placed on the painting for the cut. By tacking it in place, you can avoid slippage and potential smudging. Make sure the surface on which you're cutting is skid-proof and won't be damaged

by the penetration of the blade. Cutting surfaces are available at most art supply, quilting or craft stores. Keep the height of the table low enough that you can apply a moderate amount of pressure when leaning over the piece, helping to keep the painting and straightedge in place.

Mark the placement of the cut lightly with a pencil, then gently place the straightedge over the painting at the desired marks and score the painting with the utility knife. It's best to start with a weak incision, creating a track for subsequent cuts. If a mat cutter is being used, follow the same procedure, placing glassine over the painting and then carefully placing the painting under the cutter edge at the desired point. In my experience, it's easier to use a utility knife with a mat cutter than the mat-cutting attachment, which often cuts a distance from the metal edge, requiring compensation. Many pastel papers are abrasive and, after a few passes, the utility knife blade will be dulled and need replacement.

Different surfaces need different care. Thin papers are the easiest, often requiring a single pass of the blade. Mounted papers may require multiple cuts to penetrate the mounting board. Rigid wood composite panels, like Ampersand Pastelbord, or homemade grit surfaces are the most difficult. It's easier to cut them on a table saw in advance of painting. Once pastel has been applied, these surfaces require a good strong hand, a heavy-duty utility knife and patience. Score the board with a few passes of the knife, then place the board over a straight table edge at the scored point and snap it down. If everything goes well, the board will snap along the scored cut and only minor sanding with an emery board will be required to clean the edge.

Practice on a few failed paintings before trimming your masterpieces. With preparation and calm resolve, everything will come out fine, and your paintings will have the outer dimensions you require.

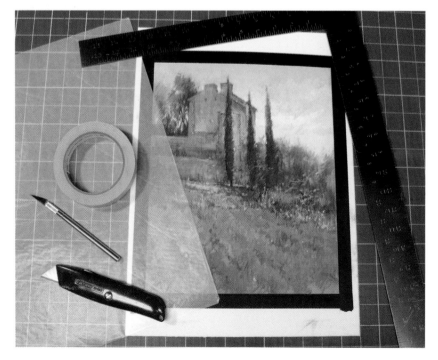

TOOLS FOR TRIMMING A PAINTING

A pastel painting in need of trimming, surrounded by a cutting surface, glassine, craft knife, utility knife, drafting tape and metal carpenter's square.

Tax Tips for Artists

As artists, we typically spend more time engaging the creative side of the brain, which can't be bothered with records and itemized lists of expenses. Creativity is great but best avoided when filling out tax forms.

If painting is mostly a pastime for you, keeping records and expensing your costs is not a concern. Even as a hobby, painting can prove expensive and being able to declare these costs against other income may be tempting. Be aware that hurdles must be met. It's best to contact a well-trained tax consultant for advice. If you're pursuing painting as a career, though, learning to keep accurate records and knowing what can be deducted becomes imperative.

Please note, I am not an expert on tax matters and certainly not an accountant; however, having done this for many years has led to a few observations that might prove helpful:

- **Find a professional accountant or tax preparer and build a long-term relationship.** Quick "drive through" tax businesses may not be equipped to understand the business of art. What we do is not a "cookie-cutter" business and requires a professional who has some experience working with artists. So many aspects of our lives are intertwined with the pursuit of creating art; it takes someone who understands the lifestyle and tax code to filter out what can, and cannot, be deducted.
- **Keep good records and all receipts.** Computer-based bookkeeping programs are very helpful. Personally, I use an old-fashioned line ledger (old habits are hard to break). Don't procrastinate in recording the information. There is nothing more daunting than a shoebox full of old forgotten receipts.

- **Set up a separate checking account and credit card for art-related matters.** This can make bookkeeping much easier. You know that everything on the statements had some art-related purpose. With online record-keeping, these records can be directly downloaded to accounting software, making it even easier to track those expenditures.
- **Deposit all income derived from your art, such as sales and tuition, into the dedicated checking account.** Itemize these deposits by breaking them down into separate categories of income. Add a description to jog your memory, in case clarification is required.
- **Place a small notebook in your vehicle and record mileage to and from all art-related activities**. All those trips to the art store, framer, classes, and shipping agent really add up. Even drives in pursuit of "landscape inspiration" are part of what we do.
- **If you have a separate studio space solely devoted to your art, it can provide a major deduction.** If you utilize a room within your living space, it can become a little tricky and is best left to your tax consultant to work out.
- **Classes and workshops are considered part of continuing education.** Everything involved can be deducted: tuition, travel, lodging and meals. Even the upcoming trip to the International Association of Pastel Societies (IAPS) convention is deductible.

It was Benjamin Franklin who said, "Certainty? In this world, nothing is certain but death and taxes." If painting is a major expense in your life, it may prove helpful to talk to your tax person and see if you can't declare some of it against your income, ultimately providing more money for pastel purchases.

For more tax tips for artists, visit **http:// pastelpointersbook.artistsnetwork.com**

Keeping **Records** of Your Art

Keeping track of our finished paintings and the "lives" they're having is something we shouldn't overlook. When they're fresh in our minds, we remember them, but let a few months or years pass by, and it becomes more difficult. Without good records, you'll struggle to confirm a title for a specific painting, the place where it was painted and when, its size and outer frame dimensions, the medium used, the exhibitions and galleries where it has been shown, and the purchase information.

Long ago I implemented a system (though not perfect) that has served me well. I devised a code to be placed on the back of every painting, and created a record in a logbook that references the code. Keeping track of paintings with just a title often leads to confusion ("A Morning Walk" is hard to distinguish from "A Walk in Morning"). And since I work repeatedly with certain sizes and extensively with pastel and oil, having that information doesn't help either. On the other hand, the code leads me to the exact painting and its history.

To keep a consistent chronological order, I place the code on the painting after fitting the pastel into the frame, and then enter its information in the logbook. That way I know the initial entry is made. The discipline arises in keeping the information updated. To help, I keep the logbook in my office where all my painting correspondence happens, making it easier to open the book in the moment and make the necessary addition. If I didn't, it would be too easily overlooked and eventually forgotten.

Coding System

My coding system is divided into three sections separated by a dash. The first number designates the painting's sequence in the year, the second letter or letters denotes the medium ("P" for pastel, "O" for oil, and "WC" for watercolor), and the third section signifies the year it was completed. For example, 23-P-A signifies that it was the 23rd pastel of 2009. This code is simple yet telling, often providing enough information to jolt my memory. When a client refers to this code, I can easily reference it in my logbook and review its history.

On the back of each painting, I place the code, title, medium, my name, copyright symbol, printed artist statement, and glass care information (when utilizing specialty glazing). The artist's statement I attach to the back of every painting is not formal but provides insight into my artistic goals and motivations. It begins with a brief biography covering professional interests, organizational affiliations and publications (similar to my bio on page 4), and is followed by my personal statement (see sidebar).

Record Your Work in a Logbook

The logbook entry contains: the title; medium; artwork dimensions; outside frame dimensions; location or inspiration for the painting (a brief description); a photograph of the painting; and a chronological record of exhibitions (both accepted and rejected); awards; gallery consignments (including asking price and sale price); and the purchaser when available. All this is referenced to the code number.

Keeping track of your painting's history is a wonderful way of looking back at those incremental accomplishments and your individual growth. Instead of carrying all that information around in your head, rely on the logbook and free the mind for future paintings.

My Personal Statement

Trying to capture a piece of the world around me in paint is something that has consumed my life since I was 13. It led me to study the techniques of master painters—from the Renaissance to the Modern. Oil and pastel are the mediums I use to convey this personal vision. Working very closely with nature en plein air (on location) has led to a much greater appreciation of the natural world. Photography (a useful tool) is not a substitute for being there and becoming a part of the exchange of nature, eye and mind. Light is the motivating factor; without it there would be nothing. Rembrandt was once quoted as saying, "You have but one master and that is Nature."

My goal is to capture a piece of the spontaneous dance of light across the palette of nature. Working on location forces me to get in touch with the moment, allowing no time for detailed studies of things. I hope my pieces are like a glance—when we see something that makes us linger for a moment.

CODE II- P-B

TITLE "Atmospheric Interlude"

MEDIUM Pastel en plein air

MY NAME & COPYRIGHT SYMBOL Richard McKinley ©

GLASS CARE INFORMATION

PRINTED ARTIST STATEMENT

Richard McKinley, PSA, PSWC-DP, NPS

Richard McKinley has been a professional working artist for 35 years and has over 30 years of teaching experience. He is a Signature Member of the Pastel Society of America and Northwest Pastel Society; Signature Distinguished Pastelist with the Pastel Society of the West Coast; Signature Master pastelist, Pastel Society of Oregon and a member of the Oil Painters of America. His work is represented in several national galleries and is a frequent contributing editor for the Pastel Journal Magazine. His work has been included in several books including: "A Painters guide to Design and composition", by Margot Schulzke and "Pure Color, the best of Pastel, edited by Maureen Bloomfield and James A. Markle, both are North Light publications. An avid plein air painter, Richard divides his time between painting the locations he is passionate about and reinterpreting those paintings back in the studio.

PERSONAL STATEMENT:

"I am not merely happy with producing a good painting. I strive to paint something that moves the viewer. Each one of us experiences the world around us differently, and I wish to share my vision with others. This is the gift that every artist gives."

"Trying to capture a piece of the world around me in paint is something that has consumed my life since I was thirteen. It led me to study the techniques of master painters – from the Renaissance to the Modern. Oil and pastel are the mediums I use to convey this personal vision. "Working very closely with nature 'en plein air,' on location, has led to a much greater appreciation of the natural world around me. Photography, while a useful tool, is not a substitute for being there and becoming a part of the exchange of nature, eye and mind. Light is the motivating factor; without it there would be nothing. Rembrandt was once quoted as saying, 'You have but one master and that is Nature.'

"My goal is to capture a piece of the spontaneous dance of light across the palette of nature. Working on location forces me to get in touch with the moment, allowing no time for detailed studies of things. I hope my pieces are like a glance - when we see something that makes us linger for a moment."

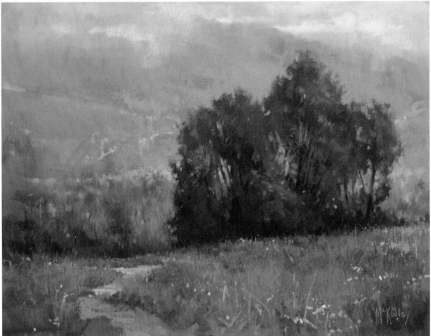

EXAMPLE OF BACK OF PAINTING

The back of this painting illustrates what is commonly behind one of my paintings: the painting's code, painting title, medium, artist's name and copyright symbol, artist statement, and glass care information when a specialty glass is being utilized.

Atmospheric Interlude, 12" × 16" (30cm × 41cm)

Shipping Pastels

Shipping artwork is always nerve-racking. If you want to participate in national and international exhibitions, you'll need to employ a suitable shipping method to accommodate your precious pastel paintings. Having helped with the intake of artwork for some of these exhibits, I could tell you more than a few horror stories of artists' work showing up with broken glass, damaged frames, and pastel dust all over the inside surface of the mat and glass. Pastel artists have worked for years to gain the respect afforded the other mediums. Exhibiting work that shows any of these problems does a huge disserve to the pastel community's reputation, and reinforces the public belief that pastel is fragile and not as permanent as other media.

The Shipping Container

Since pastel must be protected with either glass or Plexiglas, the container should be rigid enough to withstand the rigors of shipping. Commonly, cardboard is utilized and occasionally plywood. The advantage of cardboard is its weight. If the painting is at all large, plywood will become quite heavy and ends up being prone to mistreatment by the carrier. Some shippers are now adding a surcharge if wood containers are used. If you're shipping to exhibitions, you will want to invest in something that can be returned at the end of the exhibit if the work is unsold. There are companies that specialize in making boxes for this purpose, producing strong, easy to use, returnable boxes.

Shock Absorption

If you plan to make your own case, put some thought into the ease of opening and repacking, in order to make things easier for the volunteer helping on the receiving end. Make sure, whether your box is commercial or homemade, that it has a minimum of 2 to 3 inches (5 to 8 centimeters) of space around the painting to absorb shock. Bubble wrap works well, but foam sheets available at upholstery and fabric stores are even better. Packing peanuts should be avoided as they are difficult to deal with when unpacking and repacking a painting.

Plexiglas Essentials

Many exhibitions are now requiring Plexiglas (plastic), avoiding the possibilities of glass breakage. Plexiglas is prone to warping and on a large painting can easily be pushed against the surface of the pastel. Try to allow as much space as possible between the painting and Plexiglas to prevent this situation. Plexiglas also suffers from electrostatic cling. The act of cleaning the outer surface can produce considerable static, lifting pastel off the surface of the painting. There are plastic cleaners or polishes that help relieve the static buildup and are recommended if Plexiglas is utilized. Check with your art supply store or local glazer for more information. It is worth noting that Plexiglas, because of its flexible nature, can easily become dislodged from a frame if it's not fit tightly to the inner frame rabbet, especially on large paintings. If glass glazing is used, it is helpful to use a glass-skin over the outer glass layer to protect the artwork in the event of breakage. This is similar to the protective film found on most new appliances when purchased and is available from many shipping supply companies (such as Airfloat Systems). It's easily removed with no effect to the glass, and it helps to hold broken shards of glass from falling against the pastel painting should the glass become broken in transit. (Note that this is not advised for museum glass.)

Moisture Protection

For added protection when packaging a framed pastel for shipment, place it in a strong clear plastic bag. This provides extra moisture protection and helps protect the frame from abrasion. If you're using a homemade box, add thick cardboard sheets to the front and back of the painting. Make these slightly larger than the frame for extra puncture protection.

Other Enclosures

Before sealing the box, make sure you have enclosed all required information. For an exhibition, this might include the entry form, fees, return information (return label and shipping forms), and any other special instructions. Place these in a manila envelope and tape it to the plastic bag covering the painting. This makes it easy to find. If you have a box that you wish to be returned even if the painting sells, make sure to note this in the enclosed information.

Labeling

When labeling the box, print legibly and be sure to include phone numbers. Mark the top and front, in hopes that the carrier will transport the painting face up or in a vertical position. Be sure to note that the contents are fragile and should be handled with care.

Shipping

If you plan to frequently ship works, set up an account with FedEx or UPS. This makes return billing less of a hassle. Expenses will be charged to your account, allowing the shipping agent to simply affix the label to the return package and arrange for pick-up. I spend the extra amount for air service, providing prompt efficient service with less time for a package to be bounced from truck to truck.

Insurance

Insurance can be an issue. Some carriers will not insure works under glass, while others restrict the value to the creating artist to no more than $1000 per box. Educate yourself in advance as to the liabilities of your carrier. If you plan on shipping works frequently, it might be advisable to acquire separate supplemental insurance to cover your paintings. In this modern age, it's easy to follow the journey of the painting as it makes its way to the final destination by using the tracking number from the shipping label. Having an account allows me to receive an email notification automatically when shipments have been delivered. I print this out and file it with the entry information.

Accidents will happen. That is why we have insurance. However, a little effort on our part to pack our painting well and organize our information goes a long way in helping to facilitate a painting's safe arrival. Who knows, maybe it will sell and all you'll have to deal with is the return of an empty box; it happens!

READY TO SHIP
This framed painting is packaged in a sturdy, reusable box by Airfloat Systems and surrounded by sheet foam.

Preparing for a **Gallery** Show

One of the most artistically rewarding accomplishments is to be accepted into a prominent gallery and eventually be the featured artist. Seeing your work beautifully presented and appreciated by the public is a reward. It validates all the hard work and effort involved in creating something that connects with another human being.

When approached to be the featured artist, it's easy to be flattered and say yes without fully understanding what's required in making it a success for you, as the artist, and the gallery, as the agent. Most of us aren't painting for business reasons, and most galleries are; each needs the other. We provide the work and they the venue. By being as prepared as possible, the experience can be one of mutual fulfillment.

Plan Ahead

Plan as far in the future as possible—don't set an unrealistic time frame. Each of us works at our own pace and it's wise to honor our individual process. Depending on the number and size of paintings needed, this can require a considerable amount of time. Set paintings aside and don't compromise. Our most recent works are always our favorites. They're the ones we're the most attached to, and it's easy to over commit them to a variety of events. If you discipline yourself to set them aside, you'll undoubtedly have your best works when it's time to deliver the show. Think ahead and note upcoming exhibits you may want to enter. That way you can have a painting set aside without borrowing from your feature. Don't convince yourself that it won't sell, so it'll be OK to go ahead and use it. Testing this fate has put many a painter in an awkward position, damaging their reputation.

Paint With a Theme In Mind

It's never advisable to show everything you're capable of doing—it might impress your painting friends, but the public will be confused. A little consistency will go a long way in being remembered. All of us associate themes to artists and galleries have an easier time marketing someone who has a style and theme. The intention is not to be held back, or limited in scope. Hopefully, all of us will continue to grow and expand as artists, but who doesn't associate a certain theme, or style, to any famous artist? Honor what motivates you to paint. If clouds are your muse one year, and buildings the next, go for it. Everything doesn't have to be exactly the same, but a recurring theme will unite the exhibit, making it far more memorable.

Attend the Opening

Make an effort to attend the opening or reception. Even if this is the most painful aspect of the exhibit, it also may be the most beneficial. You'll hear the feedback of others, gain perspective on your work and be available to personally interact with those interested in who you are and your working process.

Catalogue Your Paintings

Make sure to give yourself adequate time to photograph and catalog the paintings. In other words, don't paint up to the evening before delivery. You need to schedule time to shift from the painting mind-set to the business mind-set to be organized when delivery is made. Have images ready as far in advance for the gallery as possible. This allows them to begin pre-sales and advanced advertising. It's far less stressful to arrive at an opening with a couple of red dots, signifying sales, than to stand around all evening eagerly anticipating that first sale. There's also a psychology of success that stimulates other collectors to commit if they see works selling quickly. If the gallery has images and prices in advance, they can begin the process of contacting previous collectors and potential collectors, and generating excitement. Showing up at the gallery organized and prepared will make their job easier and endear you to them. The happier they are with you, the better they'll promote you to their clients.

Plan the Framing Ahead

Also, think about the framing well in advance, allowing plenty of time for the materials to be ordered and assembled. Communicate with the gallery to find out what their recommendations are. They know their market and can prove to be a valuable guide in presenting your work to its best advantage. If a large body of work is required, a degree of consistency might make for a stronger statement. Not that every painting needs to be framed the same way—something often associated with a museum show—but a little cohesion will unite your work and tie the exhibit together. Don't over frame. Flatter the painting but be prepared for many collectors to want to re-frame the piece. An elegant presentation that shows the work and not the framing allows the public to appreciate the art without being turned off by the frame. Sales are often lost due to an unflattering frame, one that's either under- or overstated.

Update Your Bio

Provide your gallery with updated biographic information and publications in which you've been featured. Having these

on hand allows the gallery to better promote you to their patrons, and helps educate the sales staff about what you have been doing. The better they know you, the better they can represent you. Collectors want to know about the artist. It helps to personalize and validate their purchase.

Practice these guidelines to the best of your ability. The rewards of seeing the paintings elegantly hung and beautifully illuminated make all the effort worthwhile.

IS THAT MY PAINTING?

Here are a few photos from a recent gallery feature of mine. Too much of our time is spent with our paintings in process. We see them through their roughest stages and often hold on to those memories. Having the chance to see them all dressed up and hanging in a well-lit gallery wall is a real treat.

Fun & Lifelong Learning

The High Road
16" × 20" (41cm × 51cm)

Painting Within a **Series**

Many musical composers have worked with a theme in variation, taking a fundamental musical idea or theme and repeating it in an altered form or with different accompaniment. Adopting a similar practice as painters can lead to technical and artistic growth. By becoming submerged in a series of paintings built around a theme, you gain a better understanding of the painting process, the "why" and "what" of painting—why you are drawn to a subject and what you want viewers to feel about the finished painting. Working this way will push you to analyze your purpose, why you paint and what you portray.

Examining the different ways to portray pictorial composition—the arrangements of the visual elements of design (shape, value and color)—and considering the different styles of application

offers unlimited choices for self-expression. With repetitive interpretation, you become more familiar with the subject matter. This affords more intimacy and ultimately leads to a stronger personal statement in your work.

By definition, a series means having a number of things of a similar kind or related nature coming one after the other. The theme defines the attitude or idea of the painting. The decision to work in a series isn't always a conscious one. Many artists become obsessed with a certain subject matter or aesthetic attitude. Everywhere they turn, there's something that reminds them of that vision.

Other artists need more discipline. Left to their whims, they bounce around, never exploring any one subject or theme for very long: One day it's a still life, the next

a portrait, and then a landscape. Although variety is good, and is often what's needed to push an artist out of a rut, spending focused time with a specific subject paves the way for growth.

The physics of any painting is the same. It's a set of symbols placed on a surface—shapes, values and colors that form a kind of calligraphy that help communicate an artist's intentions. If there were one right way of doing things, artists would all paint in the same fashion, portraying subject matter with a similar aesthetic. Fortunately there's not, so artists continue to explore and grow as individuals. And the longer a painter works in series, the more intuitive the process becomes. With less thought going into the planning and execution, paintings will demonstrate a heightened expression.

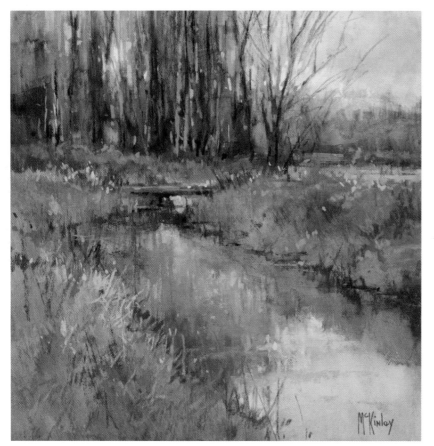

Winter Canal, 12" × 12" (30cm × 30cm)

TURN A FAVORITE SUBJECT INTO A SERIES

The exploration of simple bodies of water started as an obsession of mine a couple of years ago. Now, everywhere I travel, I find subject matter to feed it. There's a meditative and symphonic nature to the subject. Studying scenes at varied times of day and seasons has allowed me to explore many variations on this theme.

Settle on a Subject

When working in series, start by selecting the subject or theme you wish to explore. Don't think of it as being stuck with just one thing to paint; you can always move to another subject later. Work broadly, examining what the subject has to offer. After a few attempts, narrow your focus to better represent your interests.

One example might be to select a certain genre, such as portraiture, as a subject. Explore all the different aspects portraiture has to offer: old and young, happy and sad, outgoing and introspective, to name a few. After experimenting with these themes, you may find yourself drawn to portrayals of Native Americans or renderings of children, for example. If you devote enough time to this process, you'll inevitably become more technically proficient with the subject and grow into a deeper understanding of what it is you wish to portray.

Each painting, following in the footsteps of the last, shows the influences of its predecessors. The natural progression will narrow your focus and soon you'll be able to see the benefits of continued study around a certain subject. You'll inevitably become a more sensitive painter. People will be able to identify your work, recognizing that you have something to say.

Study Other Artists' Work

Much can be learned through the study of other artists' work. Seeing how they portray similar subject matter provides possibilities for your own. Name any famous artist and a picture of the artist's work will immediately pop into your mind. Often the image is something the artist painted in a series around a theme—the moody nocturnes of Whistler, the rhythmic water lilies of Monet and the elegant ballet dancers of Degas, for example.

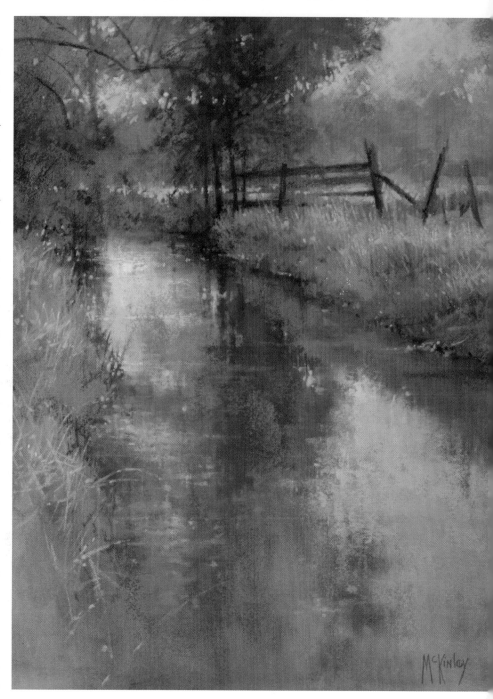

A Place of Reflection, 16" × 12" (41cm × 30cm)

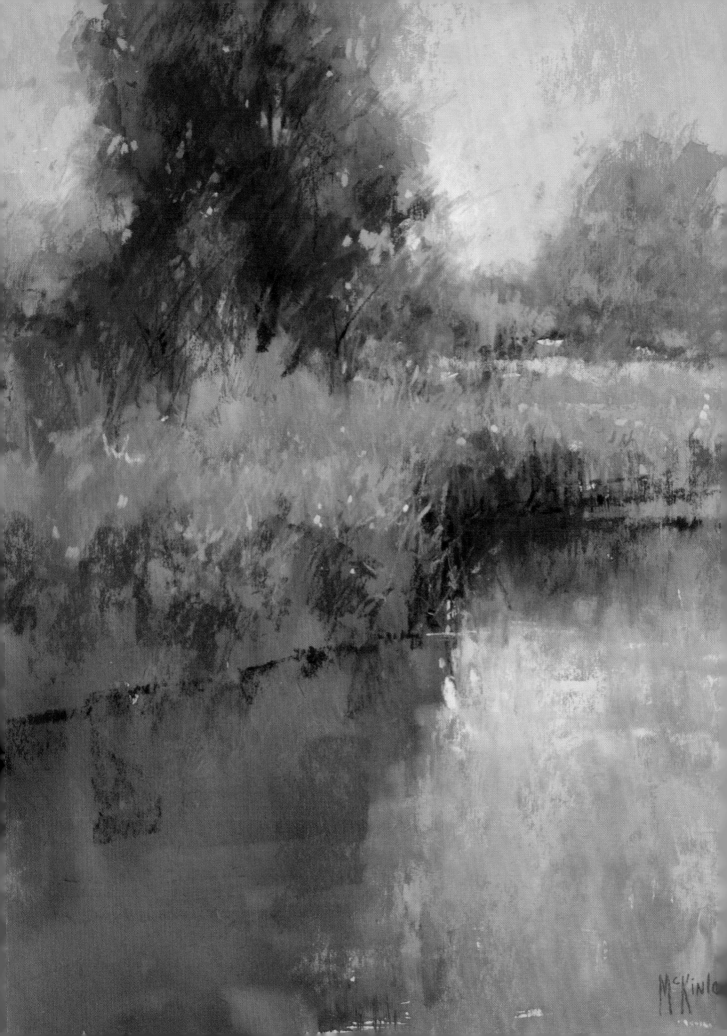

Analyze a wide variety of artists' works for comparison. Make it your goal to determine which works speak to you, and then consider what the artists did that made their work stand out. Ask questions that point to what the works you respond to have in common: Are the artists working small or large? What's the overall value scale (key) of the paintings? Is it high (light) or low (dark)? What color harmony was used most often—warm, cool or discordant? How did the artists' work evolve over time? What impact did these choices have on the final impression of their paintings? How does the artists' work make you feel? The better you understand the choices the artists made, the better you'll be able to make choices in your own work.

By working with variations on a theme, you gain a better sense of who you are as a painter and what you want to express in your work. One day you may realize you're obsessed with a certain subject, a particular way of portraying it, and a specific feeling you wish to express. At this point, you have internalized the process and are free to follow your passion with confidence.

6 Exercises for Discovering a Series

These exercises promote experimentation, a process that often leads to an idea worth exploring in a series.

1. **Try a new surface size.** *Working small or large can greatly affect a painting's final statement. The technique of applying pastel is different for each and the volume of content varies greatly. It's hard to convey the enormity of the Grand Canyon on an 8" × 10" (20cm × 25cm) surface. Conversely, it's difficult to portray the delicate nature of a butterfly when working on a 30" × 40" (76cm × 102cm) scale.*

2. **Alter the value scale, or key, of the painting.** *Purposely work lighter, and then darker. Value range can greatly alter the overall mood of a painting. A low-key painting dominated by dark differs greatly in attitude from a high-key painting made up of light.*

3. **Explore different color dominance and harmony.** *Portray one painting in a warm color family and another in a cooler family. Play with juxtapositions of complementary colors for excitement and uneasiness. Work monochromatically to create a calm passivity. Color has a lot of psychology associated with it. Explore its possibilities.*

4. **Paint in a different format.** *Try painting a scene with a rectangular format, then oblong and square. These formats communicate a variety of emotions.*

5. **Change your angle of vision and relationship to the subject.** *Looking up or down expresses a different psychological attitude about a scene. Having something close or far away makes an equally strong statement.*

6. **If painting a landscape, work at different times of day and in different seasons.** *You might develop a series of paintings devoted to a specific scene painted in the ever-changing situation in which it exists. Because the basic scene doesn't change (only the influences of the season and light), you'll gain a heightened sensitivity to what each has to offer. Change is constant: The young grow more mature, flowers wilt, and leaves eventually fall away. Painting these stages allows you to become more intimate with your subject matter, leading to paintings that are more expressive.*

Atmospheric Reflection, 16" × 12" (41cm × 30cm)

Finding **Inspiration**

To truly paint with an artistic spirit, artists have to be inspired by what they're doing. As French painter Alfred Sisley suggested when he said, "Every picture shows a spot with which the artist has fallen in love," having passion for one's subject is required. But every artist, even those with discipline, will hit a dry spell from time to time—a period when nothing seems interesting, when inspiration and motivation seem to evaporate.

Whenever I have come to this place, instead of dwelling on why I lost my motivation, I prefer instead to try one of the following remedies, which help bring me back to a place of enthusiasm.

Find New Subject Matter

If you've been working almost exclusively in a certain genre, try another and see if something exciting comes out of the change. When I'm burned out on landscapes, I often find excitement in painting portraits. After working with the different subject matter for a period of time, I bring what I've experienced back to my landscape work, approaching it with fresh eyes.

Revisit Old Themes

On the flip side, sometimes returning to familiar territory during a rut can be effective. For example, if you once worked on a series of low-horizon landscapes, you might try revisiting that idea and possibly rekindling anew the excitement you once had for that vantage point. Just because you've done something before doesn't mean that you can't find fulfillment and satisfaction in revisiting the idea with a new outlook.

Explore New Locations

For the landscape painter, a painting trip is a good bet for igniting new passion. For me, finding new places and experiencing new environments often leads to an exciting outcome. Painters are visual beings and seek visual stimulation. A change of scenery presents possibilities and fosters the desire to communicate what you're feeling. You needn't travel far or to a famous locale—just try somewhere new. Getting to experience different light, explore a change in topography, evaluate new color arrangements, and become acquainted with the character of the locale may be exactly what's needed to rejuvenate your work. I also find that leaving behind my at-home responsibilities and studio work allows me to clear my mind and slip into an artistic mind-set.

Attend a Workshop

Having the opportunity to work with another artist is a treat every artist should

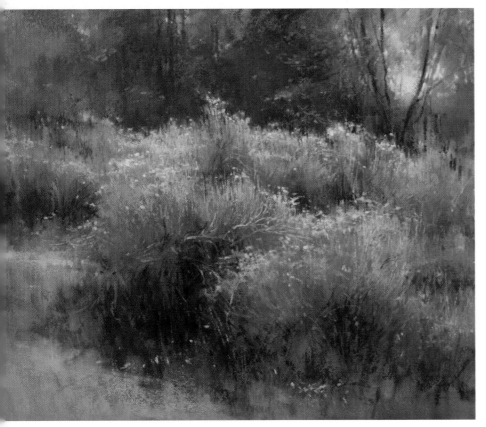

REVISIT AN OLD LOCATION
When I needed motivation for a summer gallery show, I returned to a subject that I had passion for in the past. My idea was to paint it using a new approach, in this case a less familiar surface and an undertone (tan Ampersand Pastelbord). The departure from my usual choices revived my excitement—an enthusiasm I was able to express in the painting.

Chamisa Aglow, 16" × 20" (41cm × 51cm)

indulge in now and then. Not only will you absorb new knowledge, you'll have the pleasure of watching someone else paint—a chance to observe a different approach. I love to work with people who push me to paint outside my comfort zone. All artists have a personal vision and technical ability that they bring to their paintings. When I watch another artist at work, I experience another's aesthetic and come away rejuvenated and eager to try a new technique or to approach a familiar situation in a different way. Sometimes it's a sensitivity or boldness in the use of color, or the way edges are manipulated that will excite me, and I can hardly wait to get back to my easel and put a little of what I experienced into practice.

Beyond that, a workshop offers a feeling of camaraderie. So much of an artist's work is done in isolation that it's easy to forget the importance of connecting with others who are working toward a similar goal.

View the Work of Other Artists

Just leafing through the pages of an art book or magazine can get my creative juices flowing again. A visit to a gallery or an art museum is also effective. You can also surf the Web and experience the artistic diversity out there. Visit artist-friends and check out their recent work; a friend's passion might rub off and encourage you to rush home and start painting.

Spend time with the other arts, too. Music and literature are useful allies for climbing out of a slump. Anything that stimulates the senses can be the ticket to inspiration.

Change Your Techniques

Another approach is to change techniques. I'm always experimenting and adding new approaches, but I also find that I can become predictable with some of my

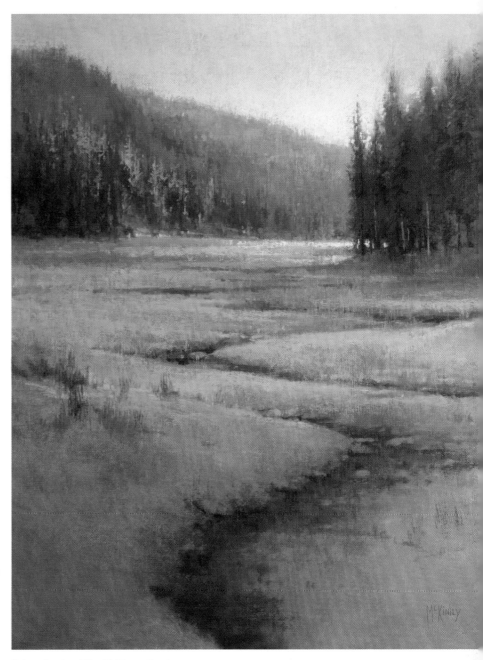

Ochoco Evening, 20" × 16" (51cm × 41cm)

SEEK OUT A NEW LOCATION AND TRY A NEW SURFACE

When I discovered this new location, I was inspired by the radiant color of the evening light on frozen snow. And, when it came time to paint, I chose a surface I rarely use: pumice grit and gesso applied to a rigid support. The combination of new subject matter and the challenge of a new surface provided plenty of inspiration.

applications. By forcing myself to vary a key component, I'm challenged to adapt and that can be exciting. There are plenty of ways to experiment: Use a new brand of pastels; try a new underpainting procedure; switch to a different surface; work on a larger or smaller scale; or change your format—from a rectangle to a square, for instance. Such changes might be taxing if you're used to working in one fashion most of the time, but the adventure of working toward a successful resolution might inject new excitement into your work.

Change is good, but a note of caution: Artists can sabotage themselves by jumping around too much—switching media, subject matter and techniques—because they believe they mustn't stay in one place too long. This can backfire, leading to a loss of motivation. It's much better to stay enthused about what you're painting or how you're painting, rather than believing you have to leave it behind as soon as you've "conquered" it. Give yourself permission to ride that wave of enthusiasm until you're done. Follow that internal voice and allow it to guide your choices. If I'm into rocks, then rocks it is! Only when the passion is dead do I force myself to find the new.

Rest a Little

It's important to acknowledge, too, that it's impossible to work at the top of your game every day. Having passion about what or how you paint is seductive, and you always want it to be there. But just as a professional athlete or musician must rest, so too must the painter. Allow yourself some time to step back and digest what's been happening in your work. Then, bring that revitalization back to the easel and see what happens.

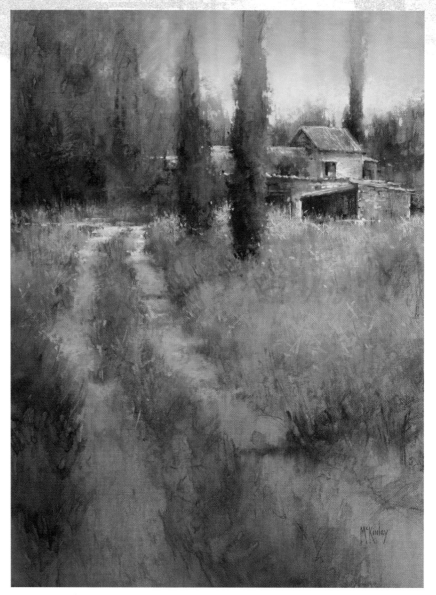

Textures of Provence, 24" × 18" (61cm × 46cm)

The life of an artist can be bumpy with many ups and downs. There are days when I experience euphoric highs that drive me to ignore everything around me as I paint, but also low points when I've little enthusiasm for applying pigment to surface. But it's comforting to know that it's an ongoing journey, and that I will eventually ride out the bumps. Taking action by using some of the ideas outlined here makes me better equipped to keep that fire burning—even if it's a mere pilot light. After all, even the mightiest fire starts with a simple spark!

EXPLORE NEW LOCATIONS

After a long, gray Oregon winter, I was delighted to travel to the south of France. The light, textures and culture all combined to create an inspiring environment. I came home with a lot of sketches and ideas that will motivate me for years to come.

Reference Books

We're all curious about the contents of other artists' studios. How are things laid out? What type of lighting is employed? What color are the walls? But one of the most interesting questions is: What art books do they keep on hand?

Books can play a valuable role in the success of an artist. They carry on a lineage of information passed from one generation to the next. A debt of gratitude is owed to those industrious teachers and painters who felt the need, or desire, to take pen to paper and place their observations, understandings, and experiences down to enlighten future generations.

Western art has had a long history of influential artist/authors and much has been made of the opinions they expressed. As valuable as these works can be, however, it's imperative that we place them in the context of their time. Scientific knowledge evolves, providing heightened understanding of the way we see and the phenomenon of light. Tastes change. What was acceptable in one time becomes passé and trite in another. However, the core observations and reasonings of these writers retain importance. As scholars instruct: If we don't learn from the past, we are destined to repeat it.

Through study of these "text books" on the craft of painting, we create our own way, adapting what we read into our process. With time we shed dependency upon them for the "answers" of how to paint and instead rely on them as comforting reminders of art foundations—of the "why" certain things work in our paintings. They become the combined observations of many generations, providing a pool of information upon which we form our individual beliefs.

Today's art publishers, such as North Light Books, continue to provide instructional art books filled with sage advice for the beginner to the advanced. Many of these will undoubtedly become the treasured studio guides to a future generation of painters.

What's on My Shelf

Acquiring copies of these books used to require a treasure hunt through used bookstores. Now with book-find sites on the Internet and public domain publishers, picking up out-of-print treasures can be a mouse click away. Digital versions are also becoming accessible as PDF files that are easily downloaded to a computer. Check out Google Books or do a Web search for available copies.

- **Carlson's Guide to Landscape Painting** *by John F. Carlson*
 published in 1929 —the landscape painter's bible

- **Landscape Painting** *by Birge Harrison*
 published in 1909—a series of impromptu lectures given to the Art Students League summer school in Woodstock, New York, Harrison was a teacher to Carlson

- **The Art of Landscape Painting in Oil Colour** *by Sir Alfred East*
 published in 1906—an interesting, highly informative read filled with strong opinions

- **Composition: Understanding Line, Notan and Color** *by Arthur Wesley Dow*
 published in 1899—an eye-opening exercise in design

Listening to **Music** While You Paint

Many painters like to listen to something while working. Many find classical music to their liking, while others prefer a wide range of musical genres, ranging from folk to country-western. A few even prefer hard rock or rap. The tempo of the music helps with the application of the medium and sets a mood. Besides music, talking books, talk radio, or television playing in the background can provide sensory stimulation. These non-musical background sounds may help distract the analytical over-thinking part of our brains, allowing for a more intuitive response to our paintings.

There are reasons why one works well for one person and not another. We are all different. We have different attention spans, different temperaments, and different ways of painting. These audible influences can play a big part in our work, providing energy, rhythm, mood and distraction, which translate into our finished paintings.

When working en plein air, the surrounding sounds provide the stimuli. Birds chirping, water gurgling, and the wind whispering all add to the moment. Only when the outside noises distract from that environment, like a busy roadside or crowds of people, does the need for artificial sound become necessary. If you don't want to be disturbed, wearing headphones (even if the player is turned off) can prove helpful. With the proliferation of digital music players and online music archives, it is easy to travel with your entire music library in the palm of your hand. No more records to change, CDs to switch, or tapes to untangle.

Experiment with a variety of sound influences. Over time your individual working style will emerge. You will find what works best for you. Master pastelist Albert Handell often listens to opera in his studio. When I painted with artist Glenna Hartmann on location she wore a small digital music player and listened to folk music. Personally, I prefer classical music, with a bent toward the Baroque and Romantic periods. Chamber music fits better than high symphonic. Even the individual instruments can have an effect. The piano relates to the "stroke" application of pastel, while string instruments, like the violin and cello, are better suited to the "swipe" of the pastel stick. Occasionally, contemporary dance music of the "trance" genre gets me going by providing an energetic beat. Other times a background movie on a TV provides the cerebral distraction I need to avoid over-thinking. It all depends on the day and individual painting.

NAME YOUR TUNE
Digital music devices have made hundreds, if not thousands, of music choices as accessible as the flick of a finger. The portability of these devices makes it easy to paint anywhere with your favorite music as inspiration.

Preparing for a **Workshop**

Workshops afford us the ability to get an insight into the painting concepts and habits of many of our pastel heroes. Admiring finished paintings is one thing, but having the ability to watch a hand in action is priceless. Having had experience with both workshop-taking and workshop-giving, here are a few observations that may help ready you for your next workshop adventure.

- **Set personal goals and keep them realistic.** Asking ourselves what it is we hope to learn or gain from a workshop makes it easier to know what to request from the instructor. I constantly remind my students that I am not a mind reader. It is their job to ask and mine to respond to the best of my ability; it's a team effort.

- **Put effort into the requested supplies.** If a certain technique is identified with an instructor and we wish to emulate it, the supplies are likely very crucial. This is where technique and broad painting theory pull apart. Techniques are often tied to procedures and materials, while theories are the concepts and aesthetics behind individual choices. Both work together in every artist's work but can be applied individually to our own. In some workshops I want to learn how they put the paint on. Here, supplies would be very important. At other times, I want to understand the artist's composition, value and color choices. This information is not so supply-dependant.

- **Take chances. Experiment. Make a mess.** Painting safely only allows us to prove to the instructor that we do indeed know how to paint. While this validation from someone we admire is useful, it is rarely the purpose of the instructor. Most are motivated to challenge the participants with new ways of seeing and doing. Bring some photographs of finished work you are proud of to show the instructor. Then, spend the workshop taking some chances. Real painting growth will come after the event when you have had time to digest.

- **Work with someone you respect.** While there is much that can be learned from artists that we do not admire, we will be more receptive to instruction and guidance from someone we respect. We are not in a workshop to prove our methods are correct. There is plenty of time for that when we instruct.

- **The best advice I ever received was to be a student, even when instructing.** Whichever position you find yourself in, enjoy it!

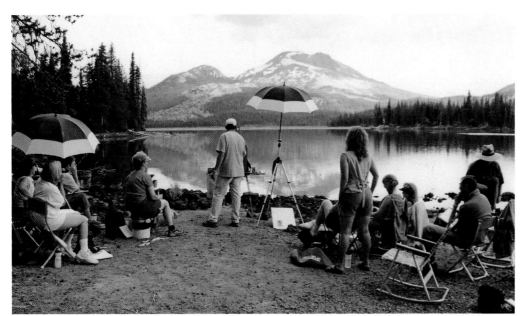

HIGH IN THE CASCADE MOUNTAIN RANGE | BEND, OREGON, 2005

THE JOY OF GROUP PAINTING

It is always a pleasure to share the beauty of painting en plein air with a group of workshop students. Seeing finished paintings may be inspiring, but watching the process unfold can provide the information often needed to improve our work.

Critiques

Criticism is a valuable part of our process as painters. Getting the opinion of others opens us up to possibilities we may have overlooked or not been capable of finding on our own. Being able to capably receive these opinions as well as dispense them is a skill we all need to acquire.

We work hard on our paintings and do our best with the knowledge and skills we have. At times this makes it difficult to hear what others might have to say. Many of us are seeking validation and approval instead of constructive criticism. Before opening yourself up to scrutiny, make the decision to learn something from the feedback. You will be better able to accept what you are told. Get a wide variety of criticism whenever possible and scrutinize the source before accepting the feedback. Comparing the diverse comments and looking for repeated observations may help us to address ongoing issues in our paintings. Make sure that the critic is able to explain objectively the reasoning behind his or her opinion. Simply stating that he or she likes or dislikes something is a matter of personal taste and serves only to flatter or tear down the individual receiving the comment. An explanation of the "why" behind the criticism will enable an artist to learn from it. Seek feedback from those you hold in high esteem—it is hard to ignore. But keep in mind that there's something to be gained from everyone. Many a good point has been made from someone who knows very little about painting.

When critiquing others, try to be objective. Create a dialogue with the artist and get a feeling for what it was they were trying to communicate; put yourself in the artist's shoes and speak at her ability level. That way, you'll be better able to explain constructively your comments and, with your criticism, encourage the artist to move ahead to the next level. Your purpose is not to make the artist more like you, but to help strengthen ability.

Critiques are a useful artistic tool, helping us to better communicate and offering a reality check for what's successful and what needs attention in our paintings. Always listen to your internal voice before handing your final decisions over to another. Remember, it is but one person's opinion.

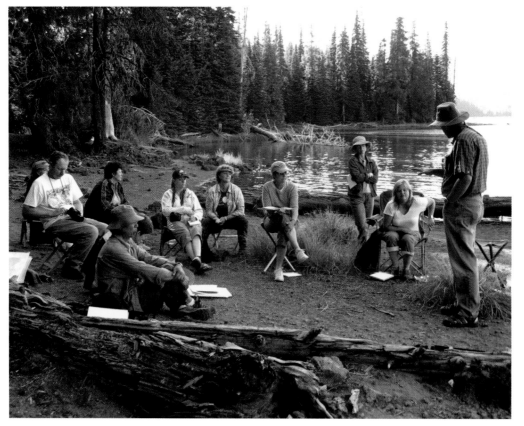

RECEIVING ADVICE
Here, the painters in my advanced plein air workshop on location in Bend, Oregon, meet for a group critique at the end of a long day of painting. Having feedback before approaching another painting day is useful; it helps solidify what's going well and what needs work, and can help expedite the learning experience.

Photo by Elloie Jeter

Keep a Painting **Journal**

Whether you're a person prone to keeping a diary or not, keeping a painting journal can prove to be invaluable. Placed near your easel while working in the studio or close at hand while painting on location, a painting journal allows for notes and observations to be recorded while they're fresh in the mind.

Some artists prefer to keep daily records much like diary entries. They record the happenings of their artistic day and make note of what they hope to accomplish tomorrow. Others prefer to record thoughts specific to an individual painting by writing down technique notes and conceptual goals specific to an individual painting. This reminds them of where they left off when last they painted, making it easier to slip back into a painting. I prefer to do a little of both, making notes of the painting day from a philosophical perspective as well as recording technical painting notes to spark my memory when I return to the easel.

To record these thoughts, find a book that meets your individual needs. If you plan to make written notes exclusively, a book designed for journaling with lined or blank pages may be sufficient. If you plan to make sketches along with notations, an artist quality sketchbook will be required. A standard run-of-the-mill sketchbook will work for most pencil work. If you plan to do ink or watercolor sketches, a heavier weight paper should be considered. A few years ago I discovered an 8.5" × 11" (22cm × 28cm) Note Sketch Book made by Bienfang (available at Dick Blick and other art supply outlets) that has worked very well for my studio journal. The pages are divided with one part lined for writing and the other left blank for sketching. They are available in a couple of sizes with the division being either horizontal or vertical.

This allows me to make notes, along with a sketch or color notations on the same page. When on location, I tend to use a sketchbook with heavier paper since I often do a series of value thumbnail sketches with ink markers and the ink will soak through lighter-weight paper. Notes can be made on the facing page to the sketch.

No matter what means you employ for journaling, doing so will prove invaluable in the future. Reading back over the entries reminds us of what we were thinking when we were in process with a specific painting and allows us to reminisce about just how far we've come in our painting.

MY PAINTING JOURNAL
Record your daily thoughts and technique notes, and set artistic goals with an artist's journal.

Conclusion

MOST OF US COME TO WORKSHOPS OR PURCHASE
INSTRUCTIONAL ART BOOKS SEEKING ANSWERS.
We are looking for the magic recipe that will make painting
easier. While there may be good advice, and hopefully you
have found some within the previous chapters, the simple
truth is that there is no easy shortcut, only hard work. You
improve as you paint. Spending time in study is important but
devoting time to doing painting exercises instead of precious
paintings is invaluable. Professional athletes don't play a match
every day but practice incessantly. Messes have to be made to
get better. Taking a chance and applying pastel to a surface will
always teach more than hours spent on cautious thought.

Leonardo da Vinci is quoted as saying, "Artwork is never
finished, only abandoned." The longer I spend painting, the
more profound these words become. It seems there is always
something more that can be done, or some other way of
doing it. This is my inspiration. Every blank surface pro-
vides the same intimidation and every day spent painting,
a new challenge.

Others have explained the artistic spirit and motivation to
create far better than I can. What is important is not perfection,
but how much you enjoy the journey. Keep looking ahead and
never lose the excitement of the child within that is thrilled
with every new artistic adventure. Personally, I will always be
a student of the craft of painting and an awestruck observer of
the world around me. My goal is to capture with pastel a piece
of the spontaneous dance of light across the palette of nature.
Even if this eludes me, I plan to enjoy and share the journey
along the way. Hopefully, this book has inspired some of you
to do the same.

Standing Guard, 12" × 12" (30cm × 30cm)

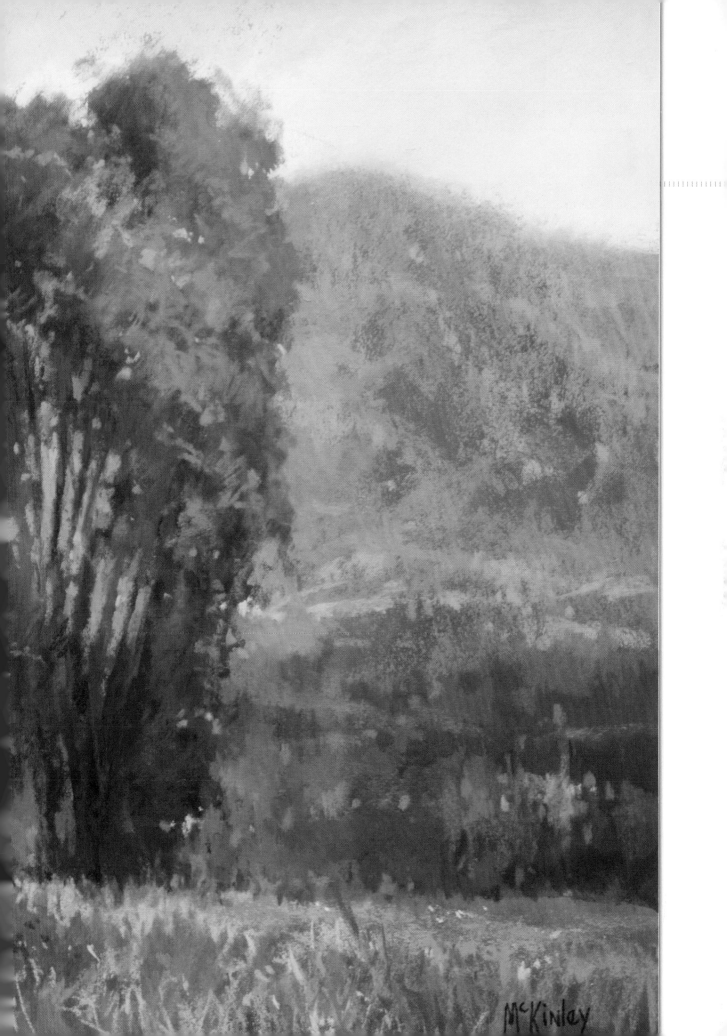

McKinley

Index

Ideas. Instruction. Inspiration.

These and other fine North Light products are available at your favorite art & craft retailer, bookstore or online supplier. Visit our websites at **www.artistsnetwork.com** and **www.artistsnetwork.tv**.

ISBN 13: 978-1-4403-0710-2
Z7709 | DVD | 120 minutes

ISBN 13: 978-1-4403-0713-3
Z7712 | DVD | 115 minutes

Sketchbook Confidential offers a rare peek inside the personal sketchbooks of 41 artists.

ISBN 13: 978-1-4403-0859-8
Z9317 | 176 pages | paperback

Find the latest issue of *The Pastel Journal* on newsstands, or order online at www.artistsnetwork.com/magazines.

Visit **www.artistsnetwork.com** and get Jen's North Light Picks!

Get free step-by-step demonstrations along with reviews of the latest books, videos and downloads from Jennifer Lepore, Senior Editor and Online Education Manager at North Light Books.